C000135981

YORKSHIRE
A CELEBRATION
A YEAR IN PHOTOGRAPHS

CHARLOTTE GRAHAM

AMBERLEY

First published 2019

Amberley Publishing
The Hill, Stroud
Gloucestershire, GL5 4EP

www.amberley-books.com

Copyright © Charlotte Graham, 2019

The right of Charlotte Graham to be identified as the Author of this work has been
asserted in accordance with the Copyrights, Designs and Patents Act 1988.

ISBN 978 1 4456 9249 4 (print)
ISBN 978 1 4456 9250 0 (ebook)

All rights reserved. No part of this book may be reprinted or reproduced or utilised
in any form or by any electronic, mechanical or other means, now known or
hereafter invented, including photocopying and recording, or in any information
storage or retrieval system, without the permission in writing from the Publishers.

British Library Cataloguing in Publication Data.
A catalogue record for this book is available from the British Library.

Typesetting by Aura Technology and Software Services, India.
Printed in the UK.

FOREWORD

Yorkshire is an amazing region. I am privileged to see so many different sides to the county, from vibrant town and city centres to the wide open spaces of the Dales and North York Moors. This is a place that will always hold a special place in my heart.

The beauty of the landscapes is matched by the diversity and warmth of Yorkshire people, and I believe that it is the people who make it so special. During my pilgrimage across the diocese, I met so many wonderful people and saw first-hand why the Yorkshire welcome has a reputation for warmth and friendliness across the world. It was a great honour to be named 'Yorkshire Man of the Year' in 2007.

Charlotte Graham is one of the Yorkshire people that I hold in high regard: friendly, but very plain-speaking, and passionate about the county. We meet regularly at events and festivals where she is capturing photographs shared across the regional, national and international media, and it is a true joy to see the world not only through the lens of her cameras, but also through her eyes. Through the photographs that you see in this book, you see Yorkshire from Charlotte's perspective. Each picture portrays a single moment in time, and yet as a collection they show us life in Yorkshire, from wildlife and steam trains, to theatre and performance. It's not called 'God's own country' for nothing – or should I say, 'for nowt' – and you see that in every image.

It is quite remarkable to think that these pictures have all been taken over the course of one year; many photographers would be happy for this to represent a portfolio accumulated over many years, but I always look forward to seeing what comes next for Charlotte. Who knows, she may even ask me to write the foreword for Volume Two...

Archbishop of York, the Most Reverend Dr John Sentamu

FOREWORD

On any random Wednesday at around 10.30 a.m., the workload and stress levels will be rising in the offices of *The Telegraph* as tens of thousands of images land in our database and the team attempt to sort the wheat from the chaff. The best kind of telephone call to receive on a morning like that is from Charlotte Graham. 'Hello! Only me,' comes the voice from the other end. 'I think I might have something for you.'

What's not immediately clear from that short statement, but becomes apparent when we see the pictures some time later, is that Ms Graham has pulled it out of the bag once again and delivered another cracker that we can plaster across all eight of our beautiful broadsheet columns to delight and entertain our valued readers.

Whether at one of Yorkshire's grand stately homes or glorious churches, out on the moorland or in the Dales, or shivering in the rain at the Commonwealth War Graves Commission cemetery, her photography is never short of spectacular. Incredibly creative and technically brilliant, I hope you enjoy the wonderful photography within these pages.

Matthew Fearn
Picture Editor, *The Telegraph*

ACKNOWLEDGEMENTS

Being a freelance photographer, I travel throughout Yorkshire and work all over the country with some amazing and very talented people. The images you see in this book would not have been possible without the help of various people who give me access to sites. The images portray a cross section of daily events, exhibitions and festivals that take place throughout the year.

A very big thank you to the following people or publications: Matt Fearn, Jason Green, Lee Martin, Sarah Knapton, Dominic Nicholls and so many others at *The Daily Telegraph*; the picture editor and staff at *The Times*; the picture editor and staff at *The Guardian*; Nick Howard, Abbi Olive, Sophie Allenby and the maintenance and gardening staff at Castle Howard; the Yorkshire Air Museum; Jorvik; Sharon Atkinson, Leanne Woodhurst and Tom Outing at York Minster; Lee Clark and Lauren Masterman at York Museums Trust; Make It York; Louise Scott, Newby Hall; Fountains Abbey; Harewood House; Kirklees Light Railway; the team at North York Moors Railway, Laura Strangeway and Peter Fisher; RHS Harlow Carr; Jay Commins and Samantha Orange at Pyper York; the Office of the Archbishop and Elizabeth Addy; Amanda Brown at A2BPR; English Heritage; the National Trust; the Canal and River Trust; Lunchbox Productions; Shakespeare's Rose Theatre; the Great Yorkshire Show and Jo Francisco; Harrogate Flower Show and Camilla Harrison; Jakki Moores at Canon UK; Manfrotto; Chris Whittle and his team of excellent staff at The Flash Centre; Elinchrom Strobe Lighting; the National Union of Journalists; BPPA; the actors, actresses and re-enactors who take so much pride in recreating costumes and heritage dress; Paul Barrett, Katie Canning, Mark Jackson, Andy Deane and the conservators at the Royal Armouries; Titch, my little girl; the publishing staff at Amberley; and all the friends and family that have helped me make this happen, including the ones who are too modest to want a mention.

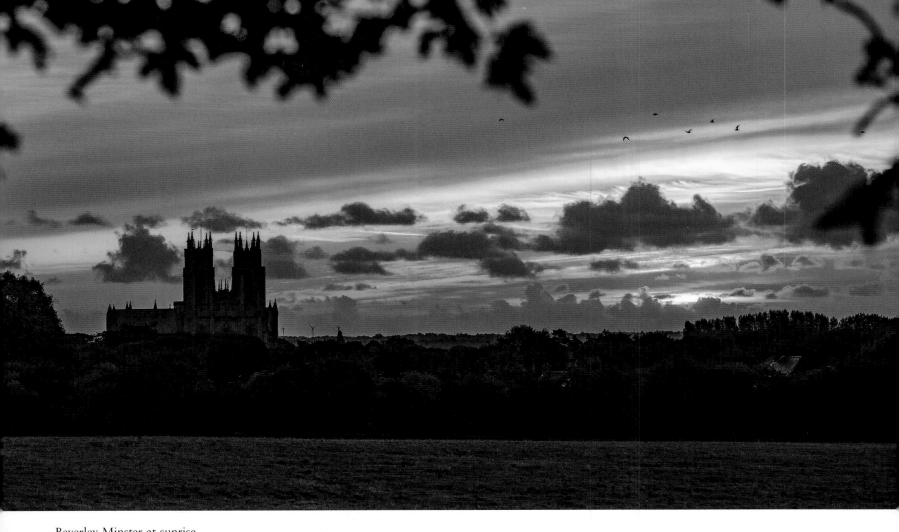

Beverley Minster at sunrise

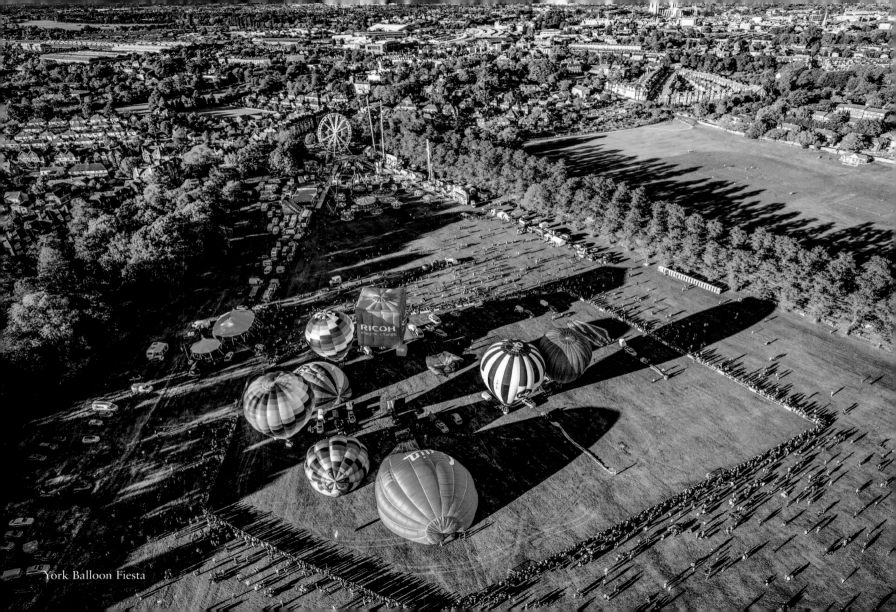

York Balloon Fiesta

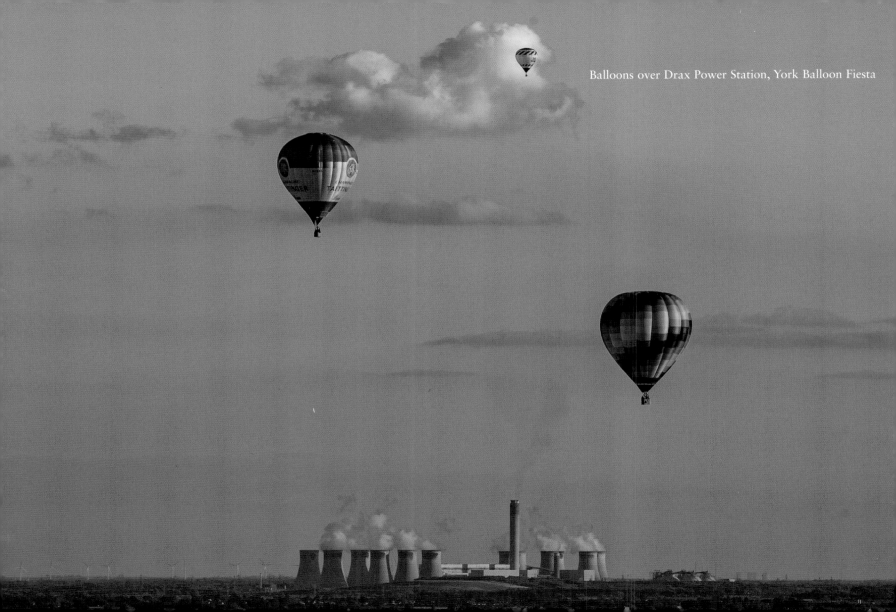

Balloons over Drax Power Station, York Balloon Fiesta

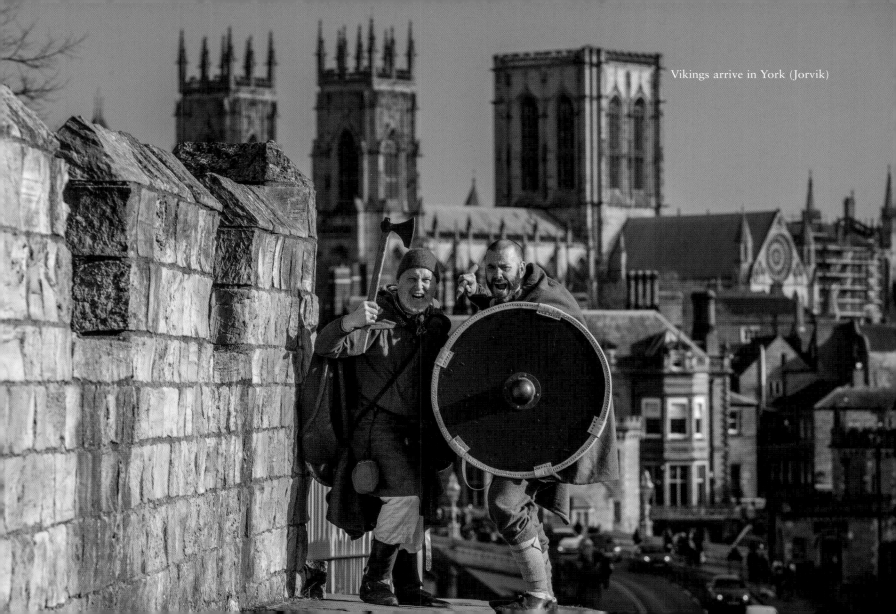

Vikings arrive in York (Jorvik)

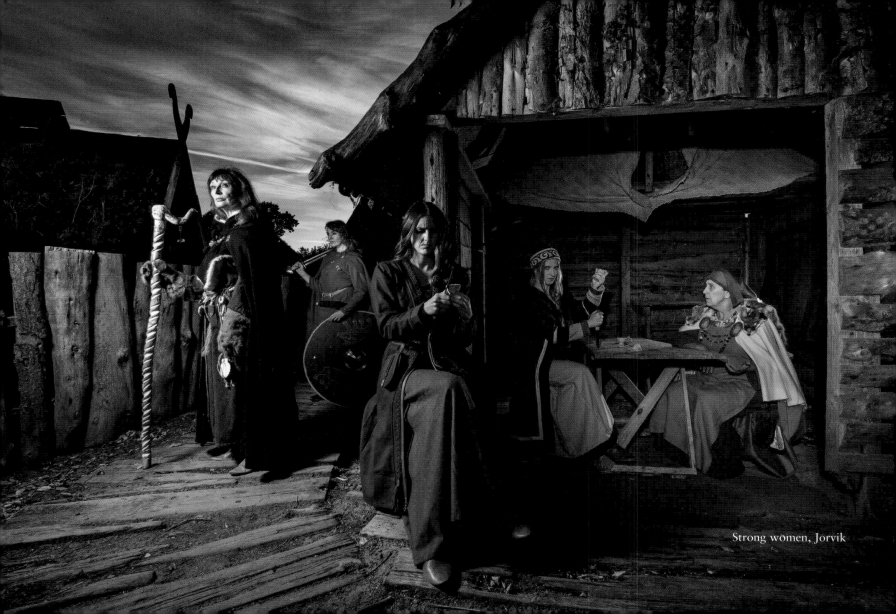

Strong women, Jorvik

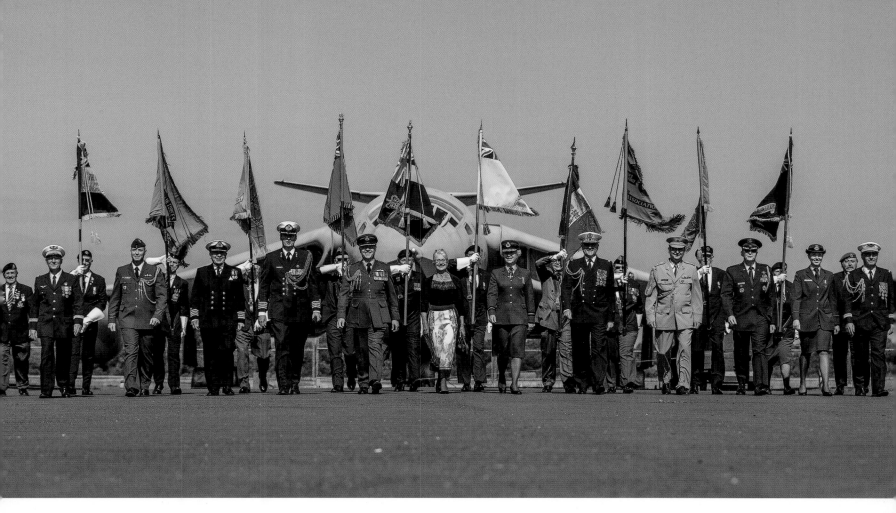

Allied Air Forces Memorial Day, Yorkshire Air Museum

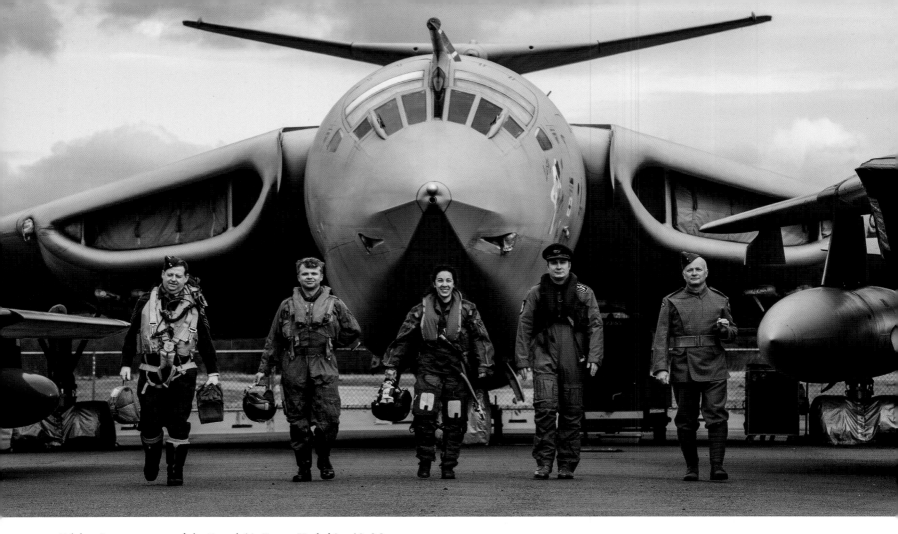

Celebrating 100 years of the Royal Air Force, Yorkshire Air Museum

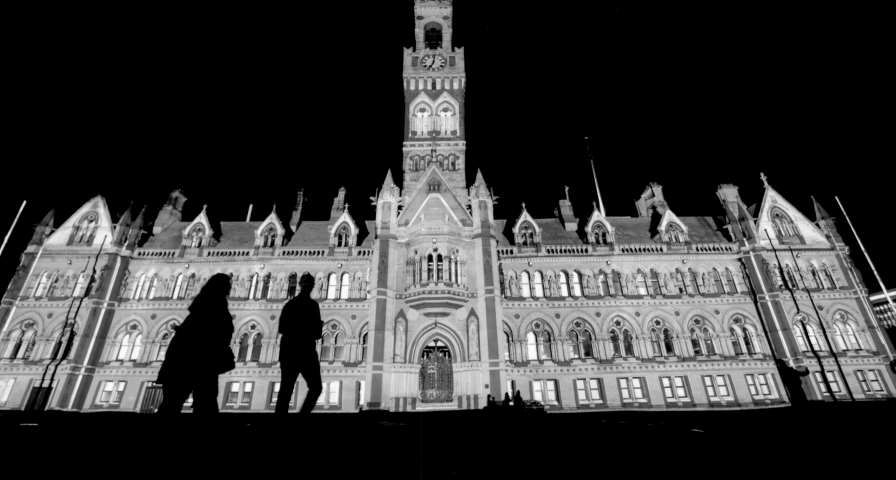

Illuminate Bradford

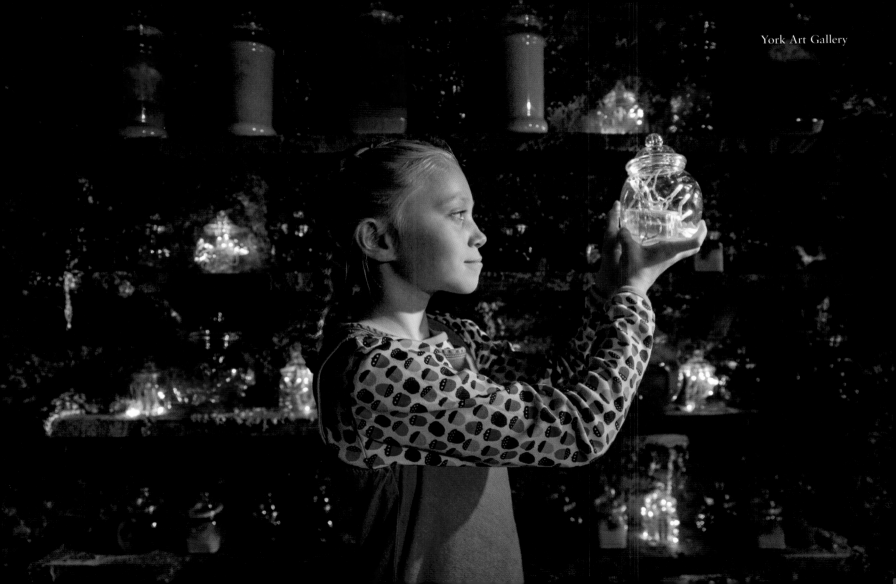

York Art Gallery

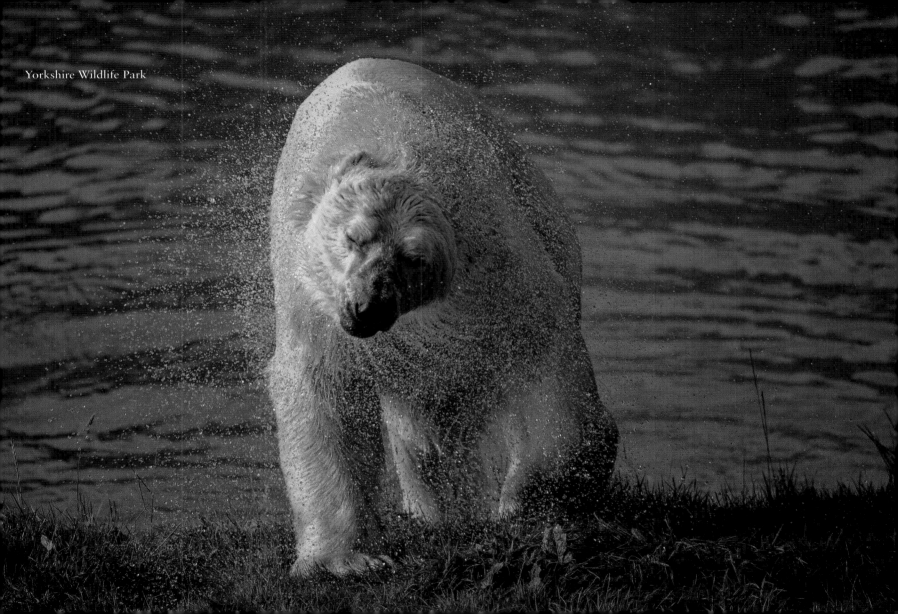

Yorkshire Wildlife Park

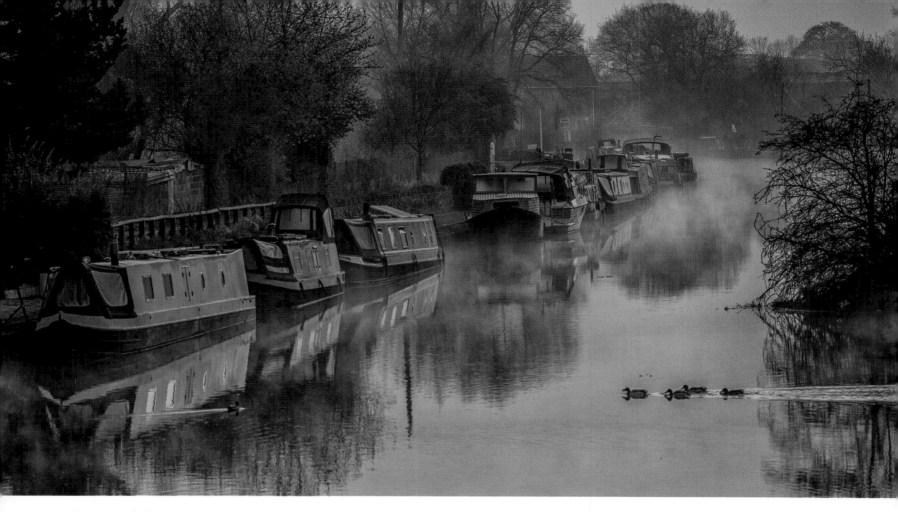

Early morning light

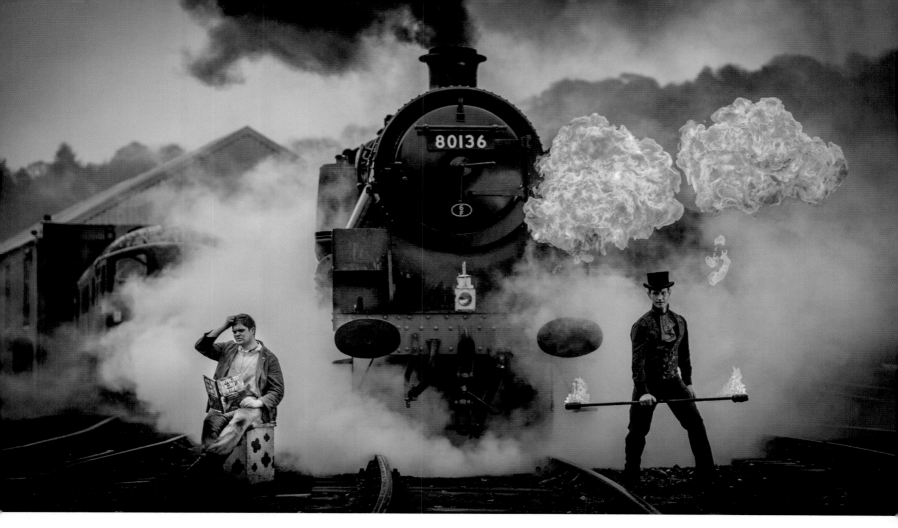

Illuminating the Future, North York Moors Railway

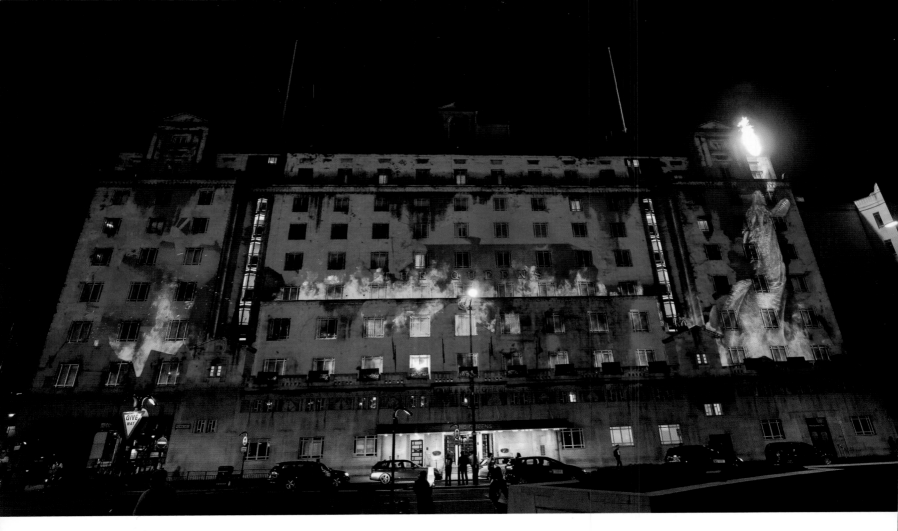

Light Night Leeds

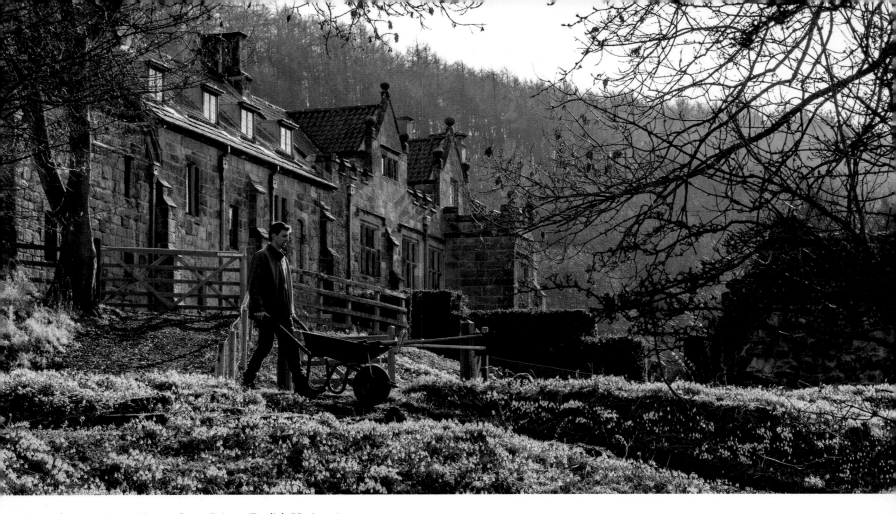

Snowdrops arrive at Mount Grace Priory (English Heritage)

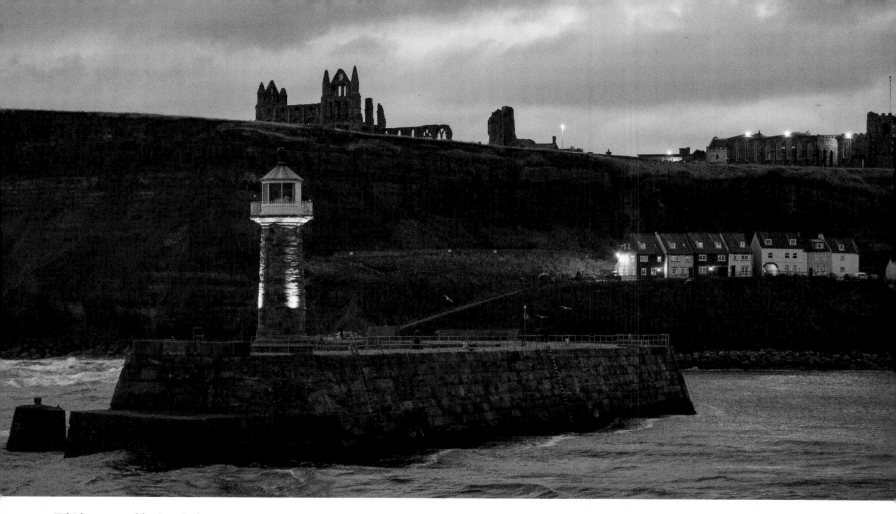

Whitby on a cold winter's day

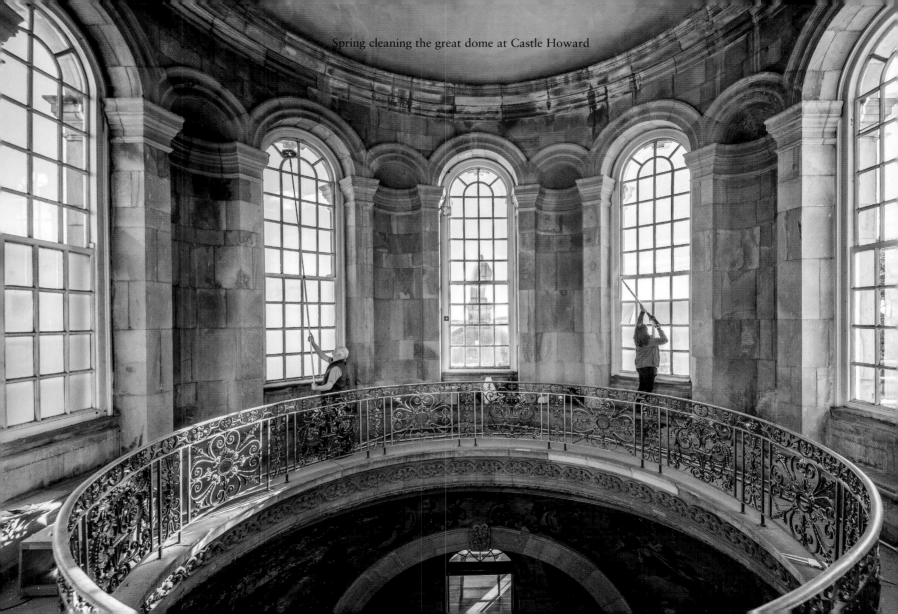
Spring cleaning the great dome at Castle Howard

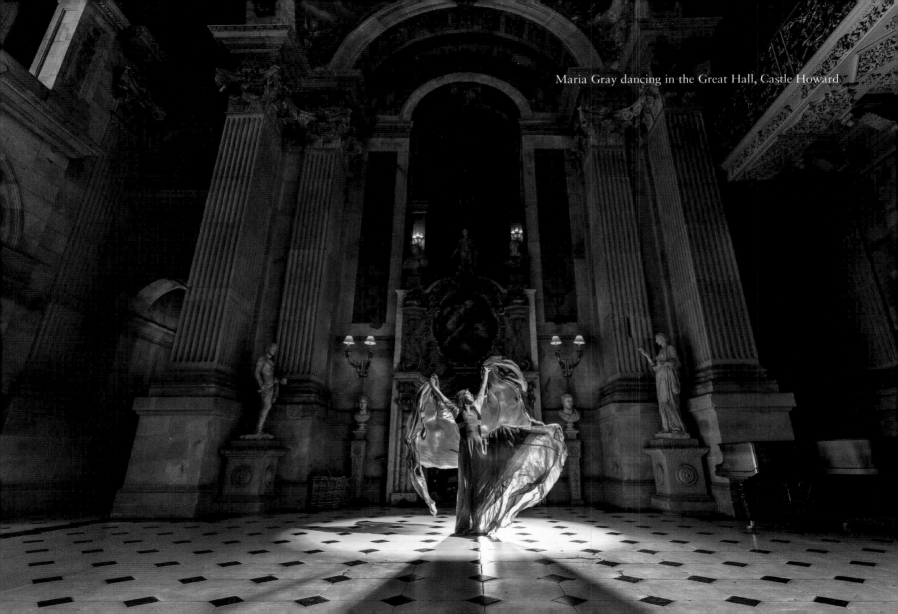

Maria Gray dancing in the Great Hall, Castle Howard

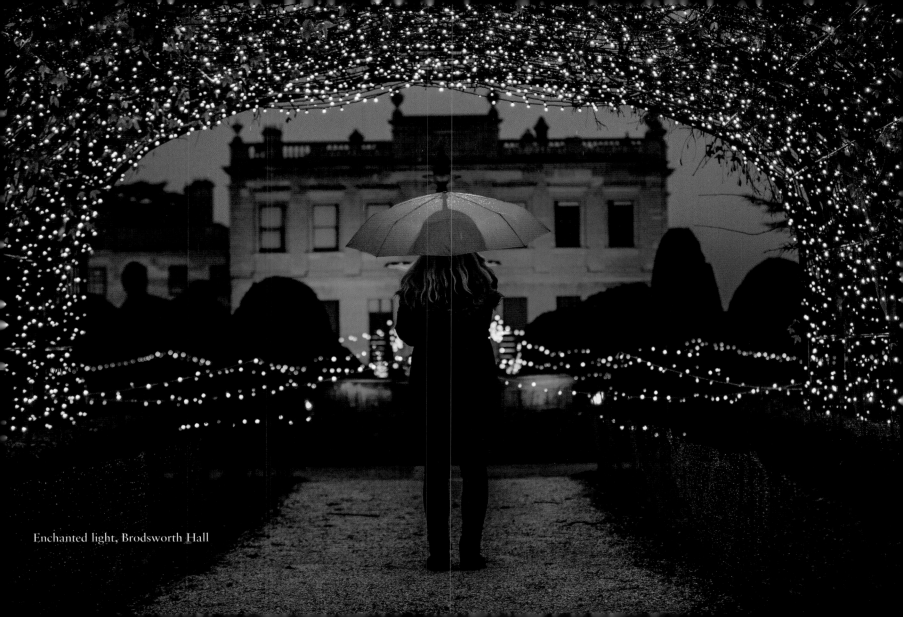

Enchanted light, Brodsworth Hall

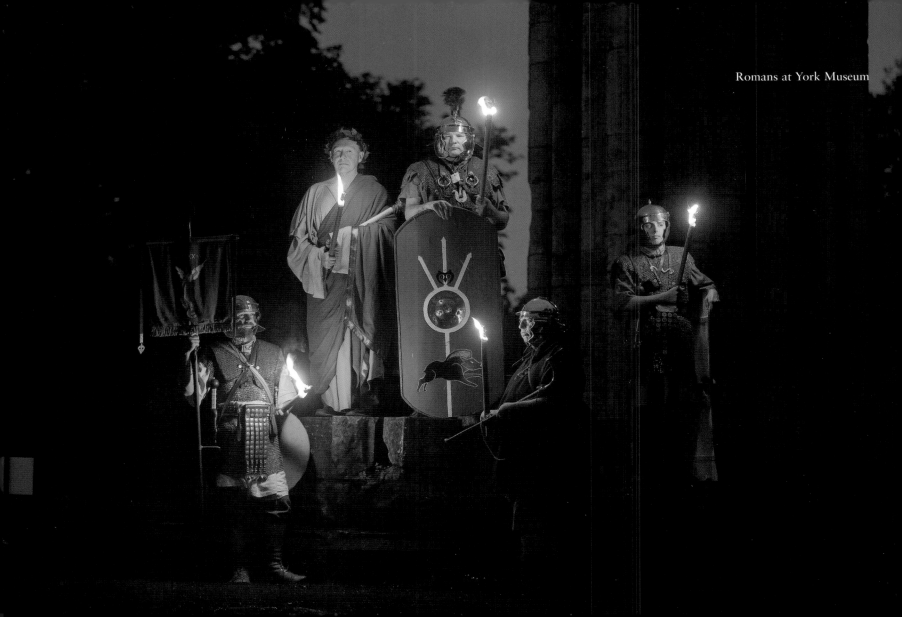

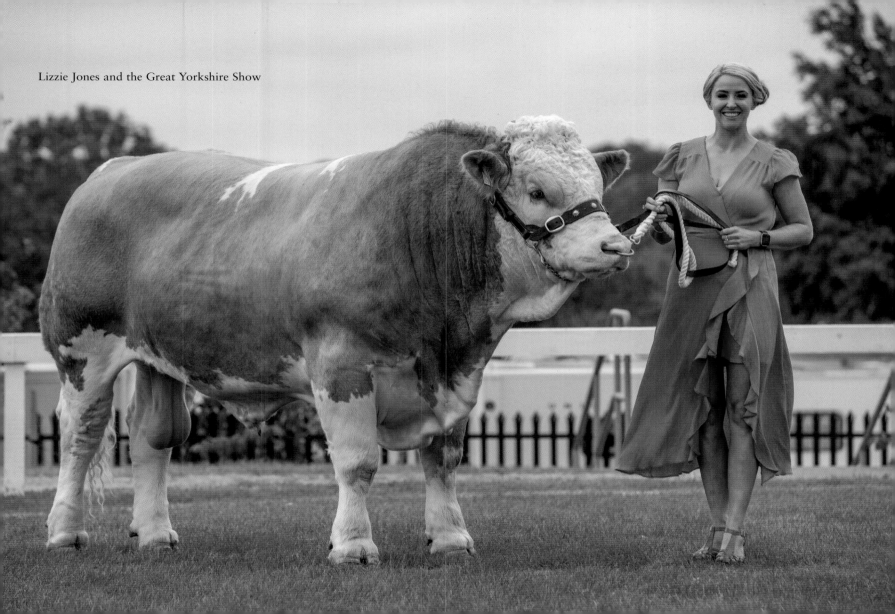

Lizzie Jones and the Great Yorkshire Show

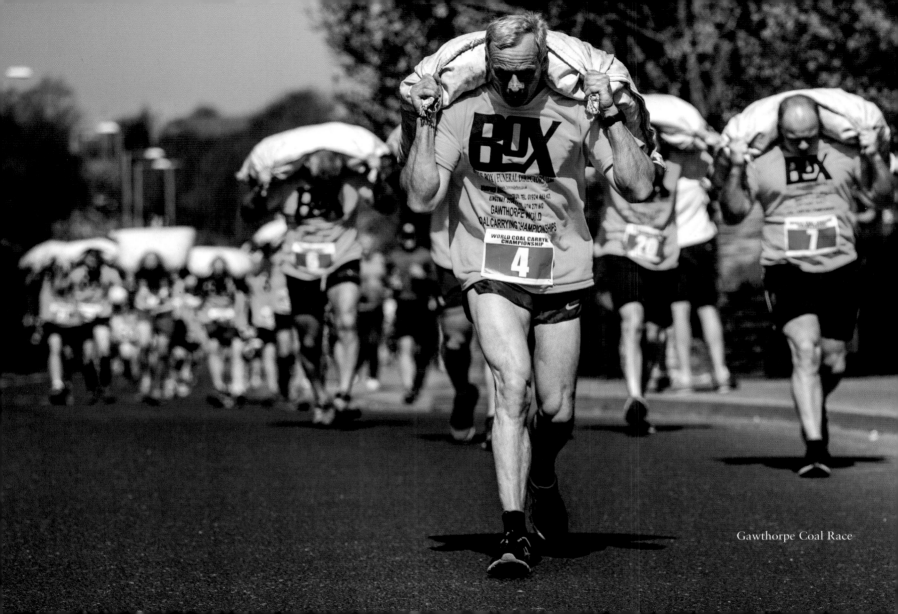

Gawthorpe Coal Race

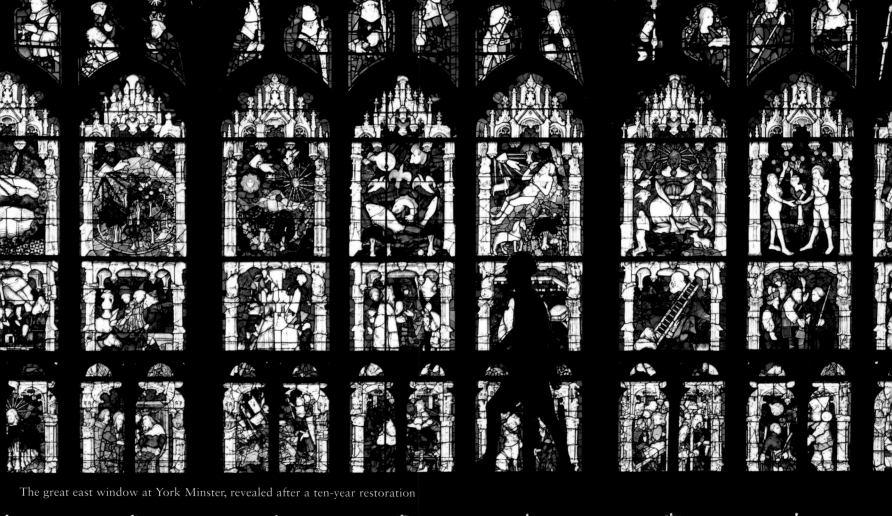

The great east window at York Minster, revealed after a ten-year restoration

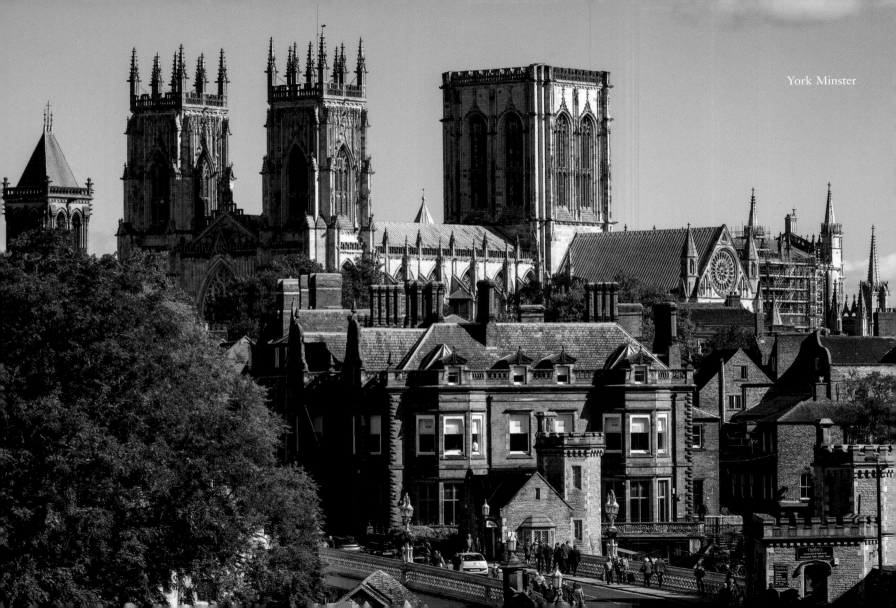

York Minster

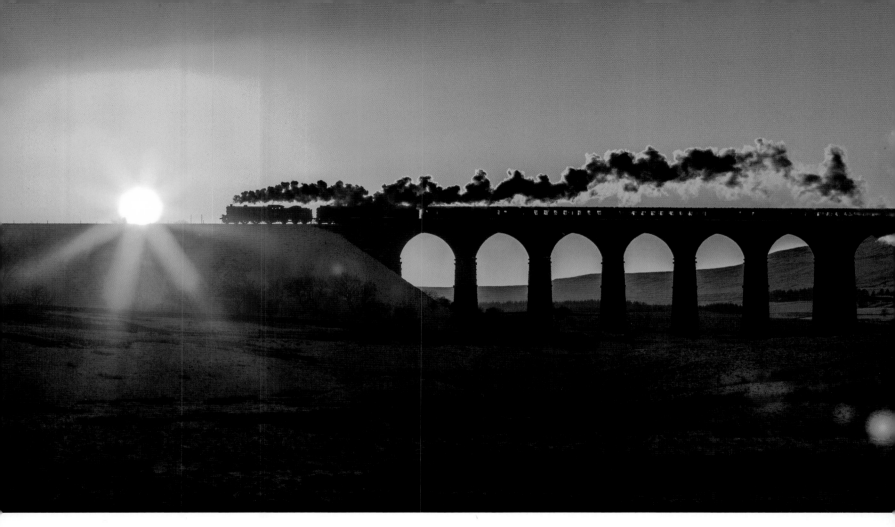

A double-header steam train passes over Ribblehead Viaduct

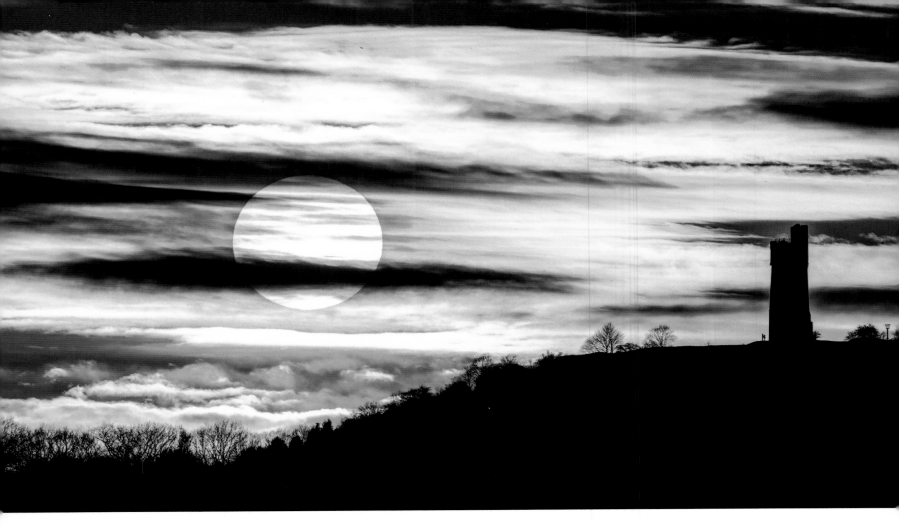

Sunset at Castle Hill, near Huddersfield

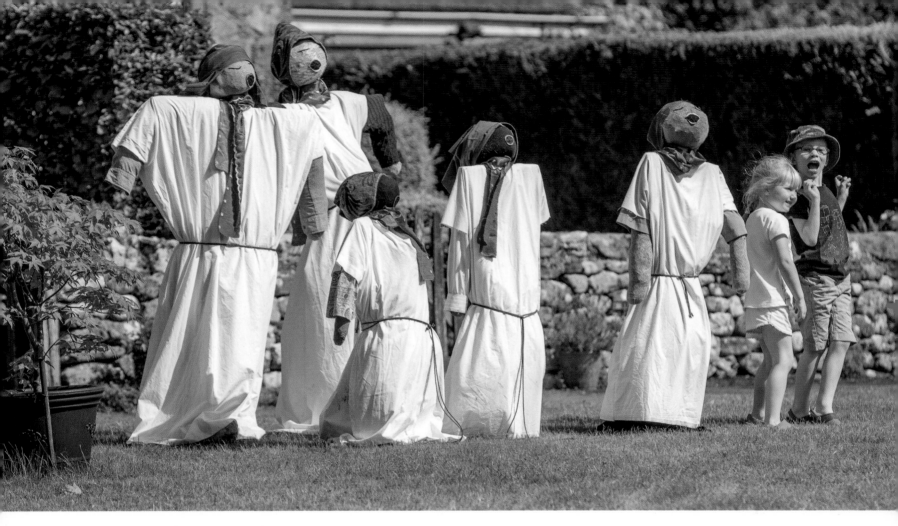

Kettlewell Scarecrow Festival

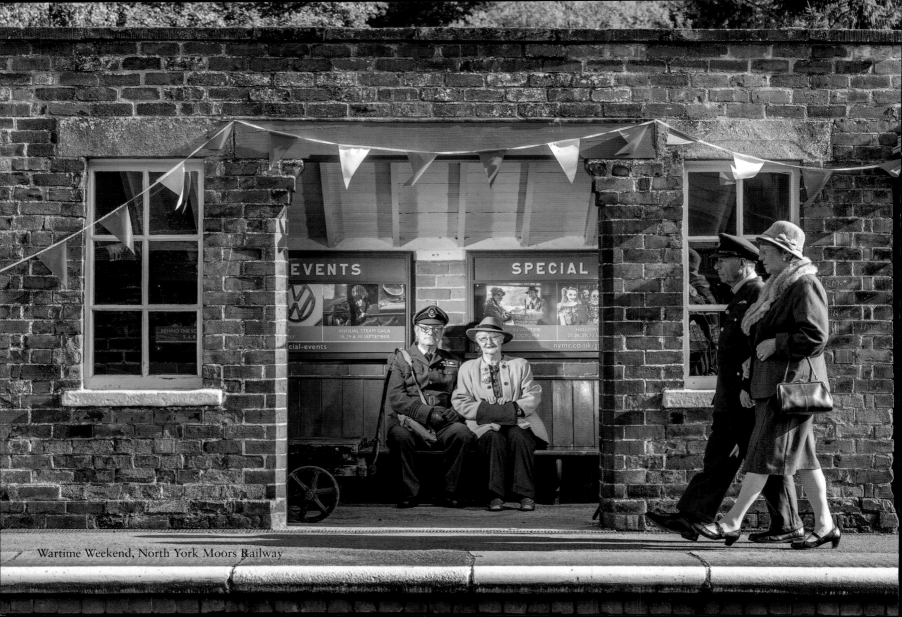

Wartime Weekend, North York Moors Railway

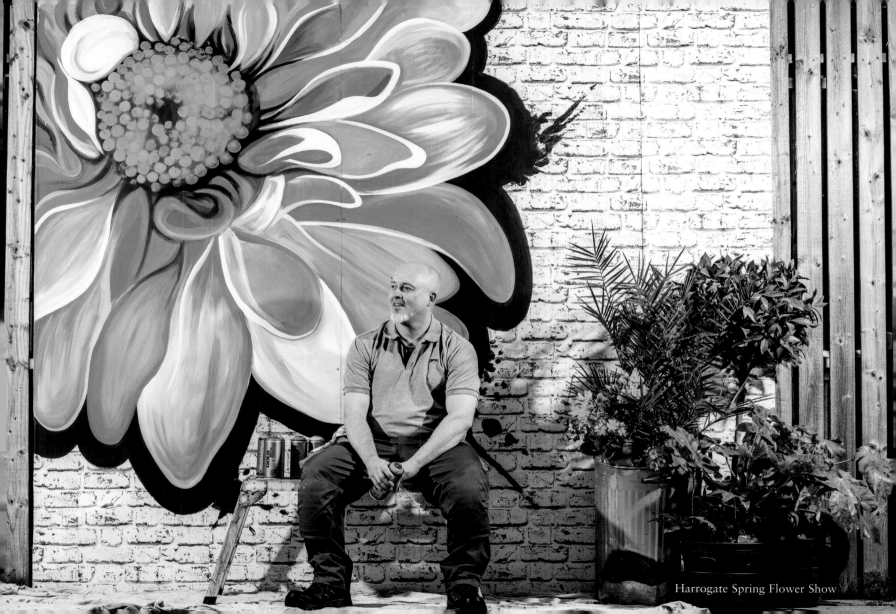

Harrogate Spring Flower Show

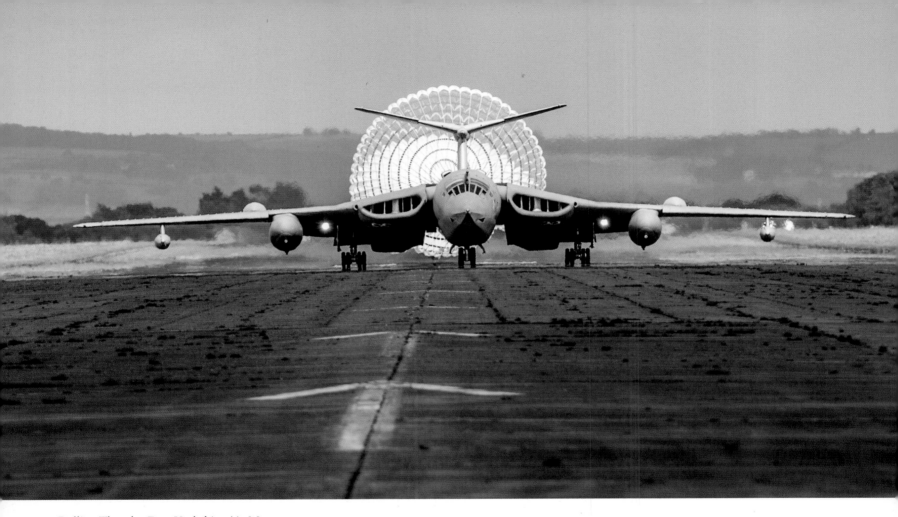

Rolling Thunder Day, Yorkshire Air Museum

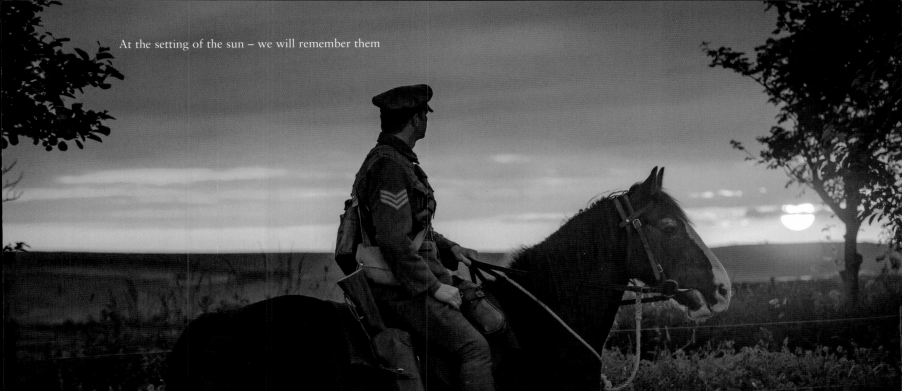

At the setting of the sun – we will remember them

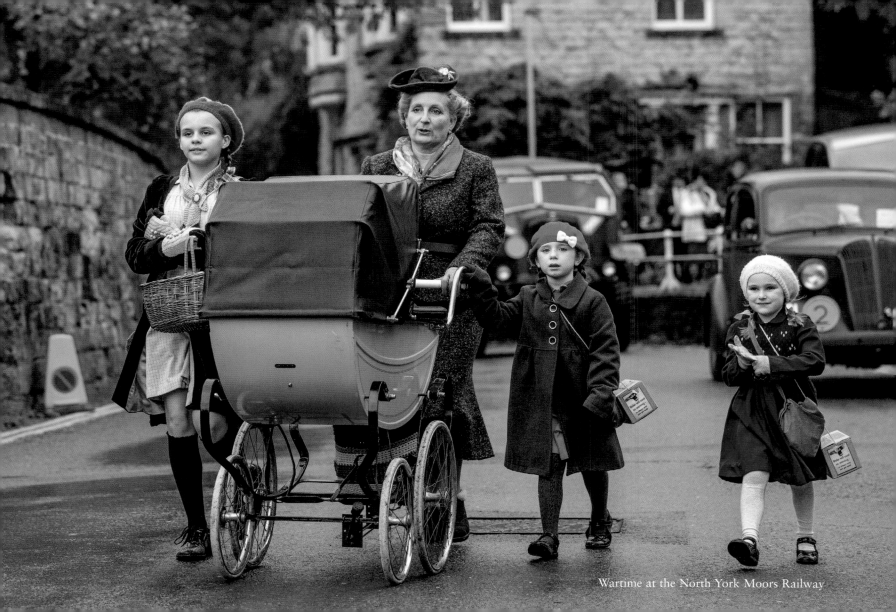

Wartime at the North York Moors Railway

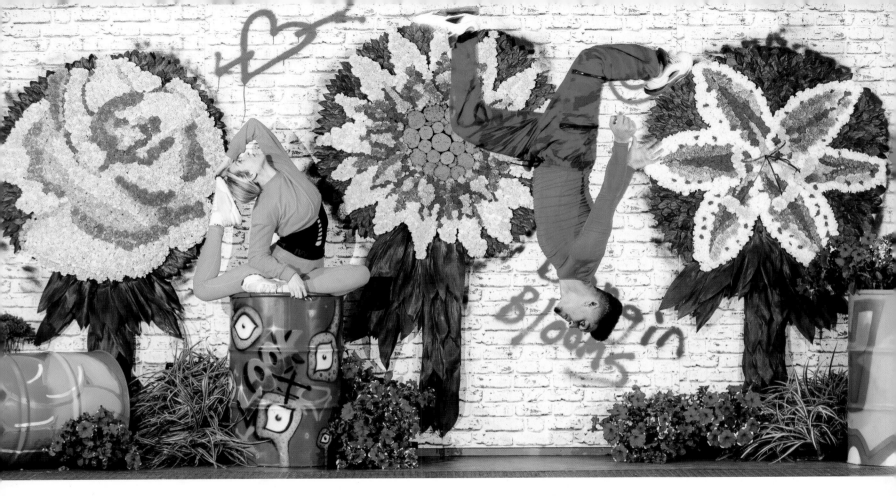

Spring Flower Show, Harrogate

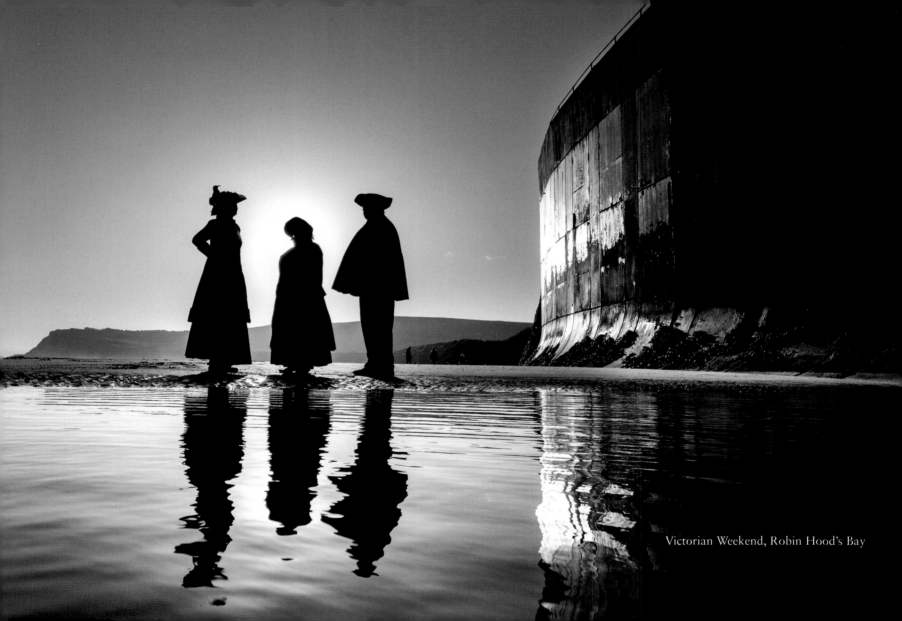

Victorian Weekend, Robin Hood's Bay

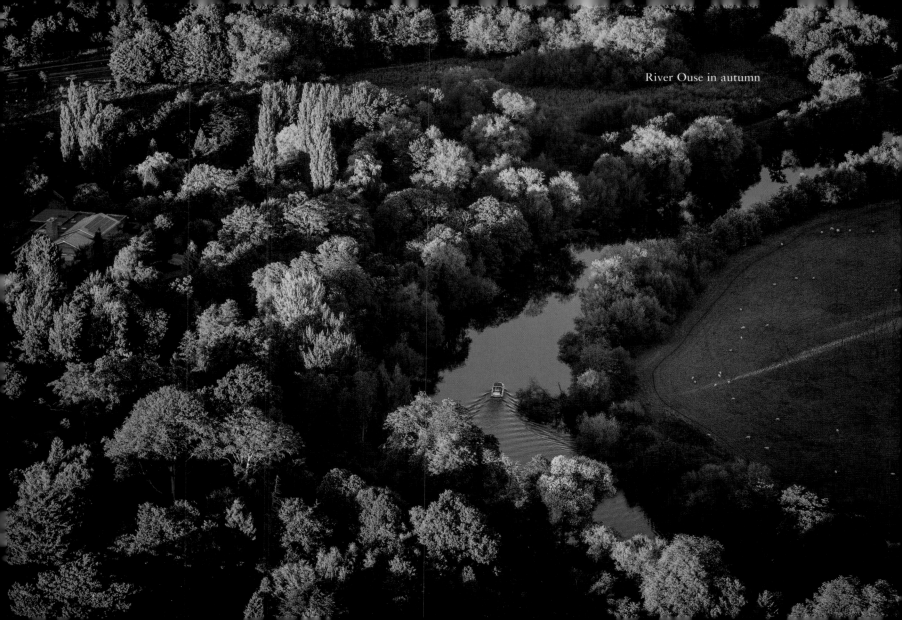
River Ouse in autumn

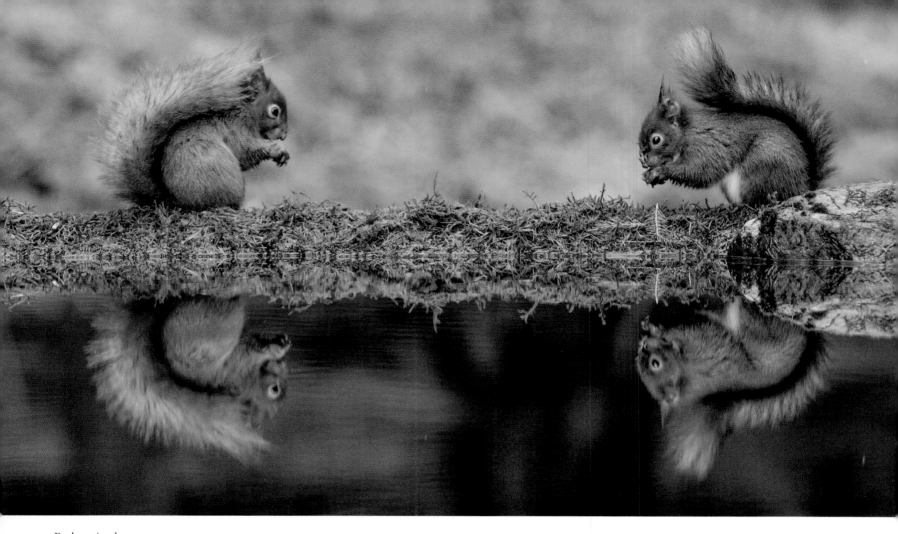

Red squirrels

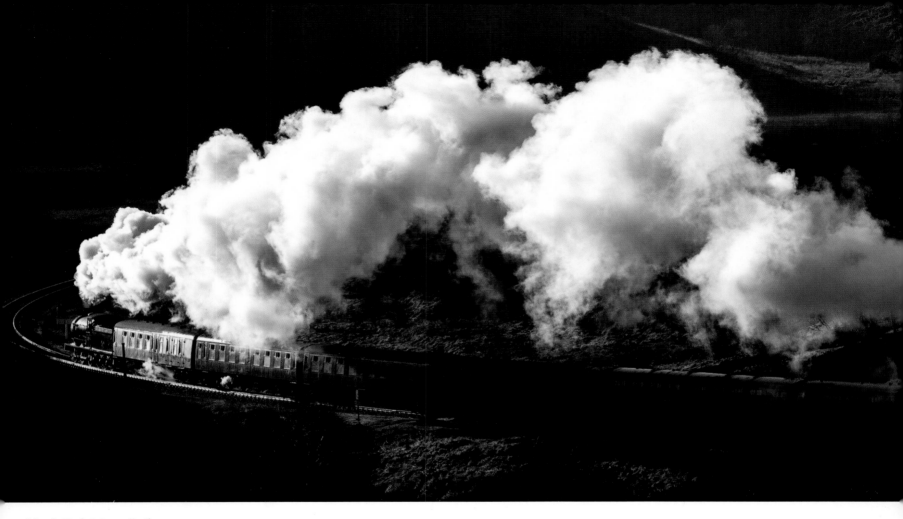

North York Moors Railway

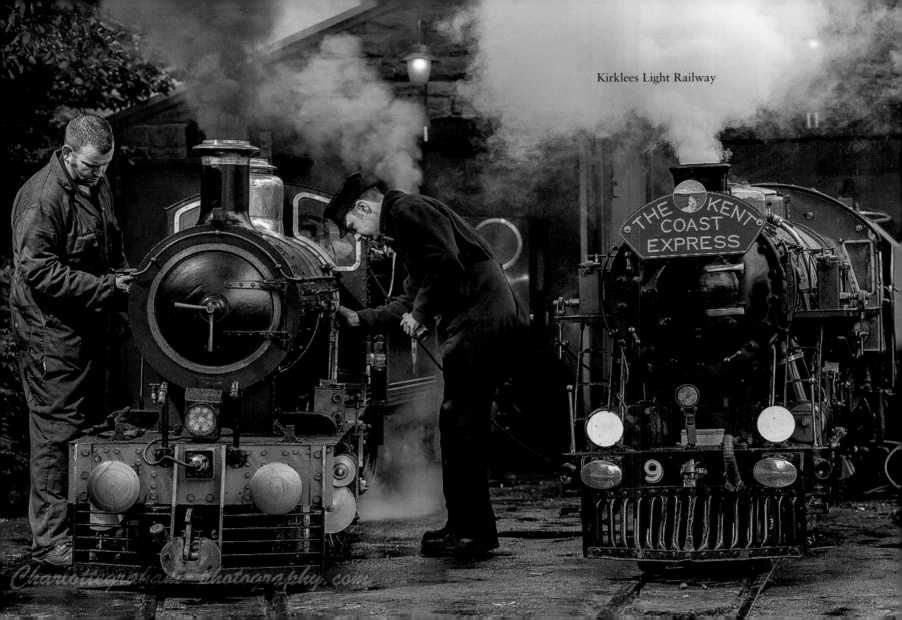

Kirklees Light Railway

THE KENT COAST EXPRESS

9

Charlottegrahamphotography.com

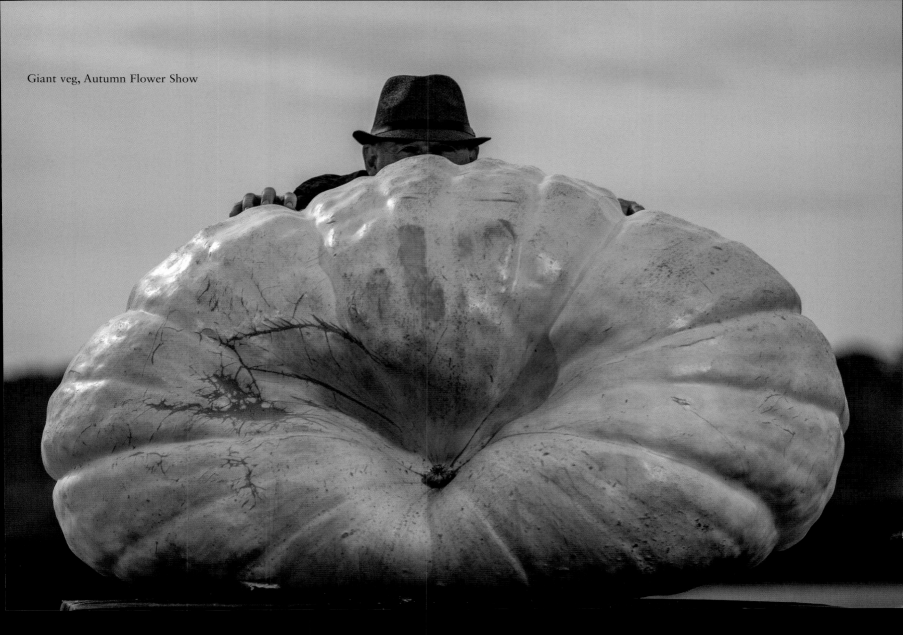

Giant veg, Autumn Flower Show

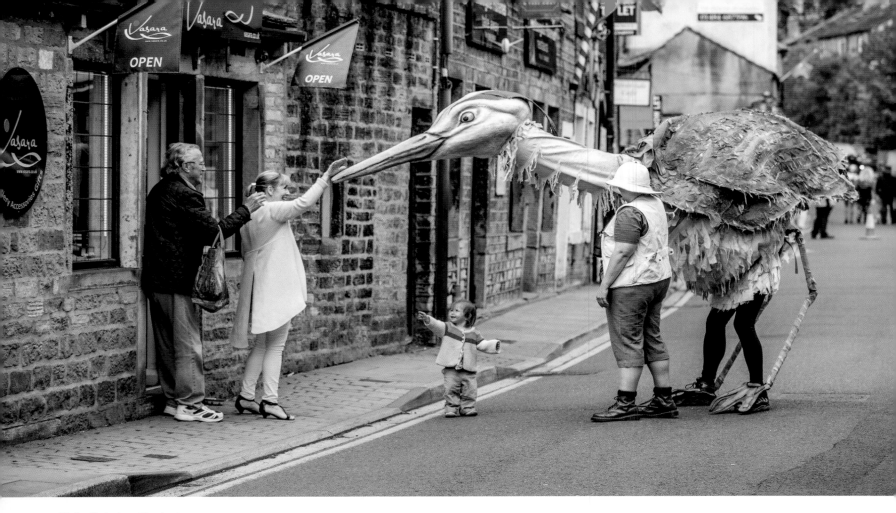

Holmfirth Arts Festival

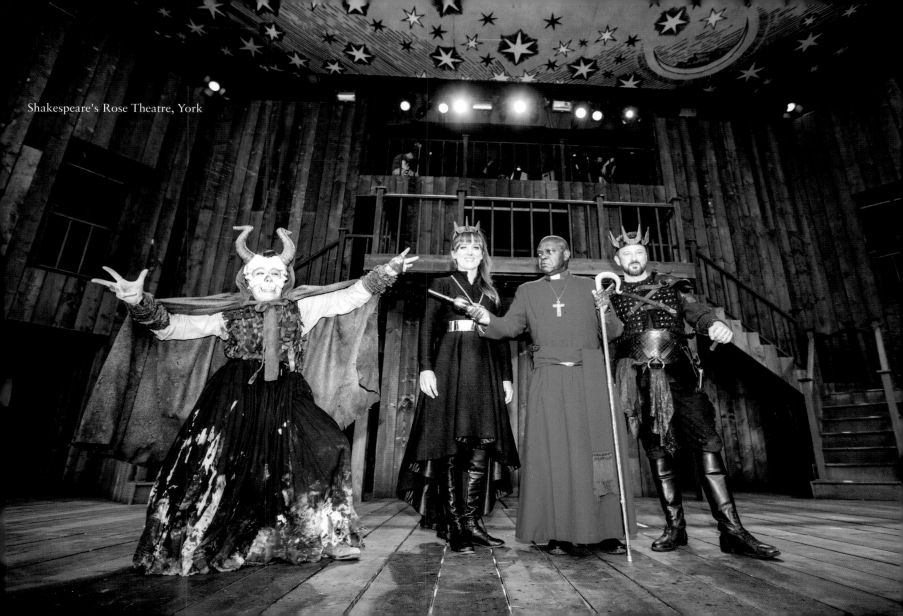

Shakespeare's Rose Theatre, York

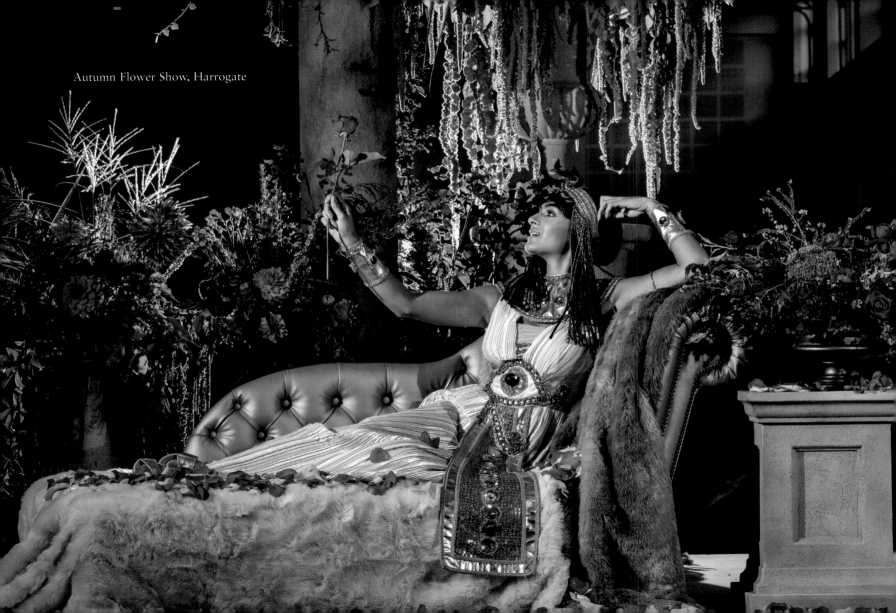

Autumn Flower Show, Harrogate

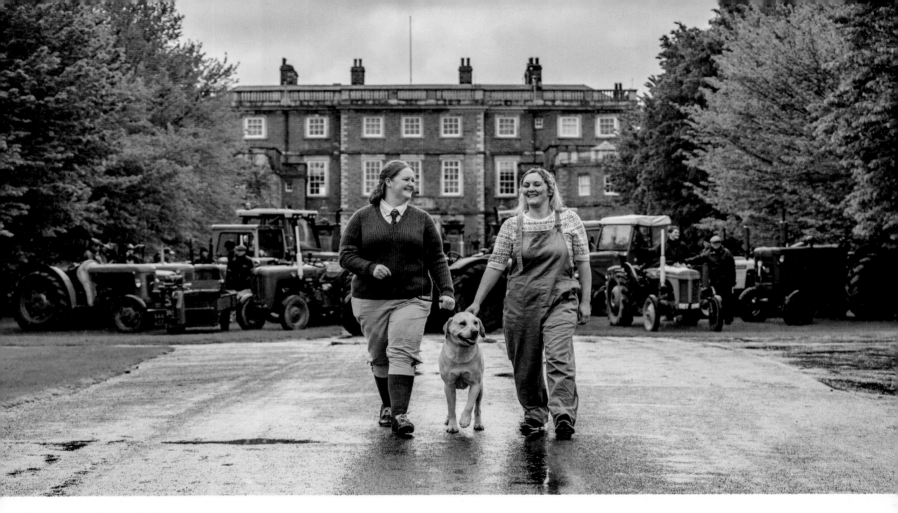

Tractor Fest, Newby Hall

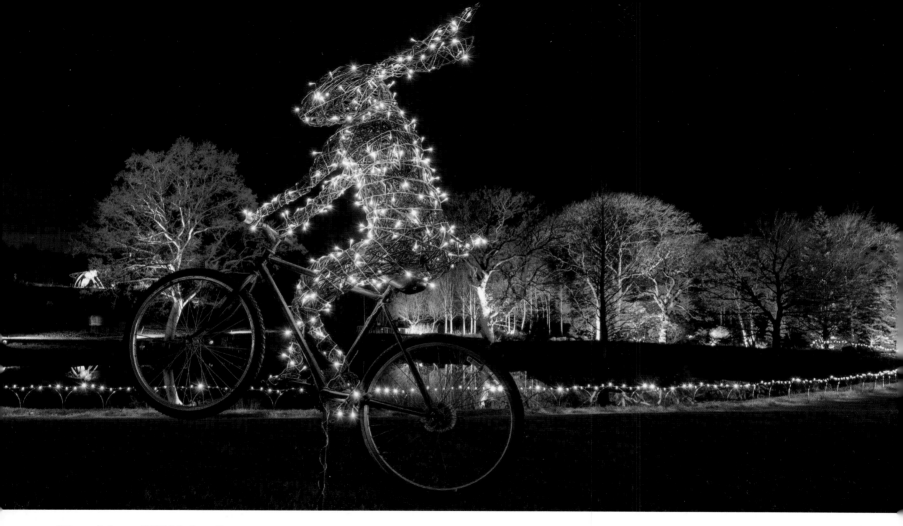

Winter lights at RHS Harlow Carr

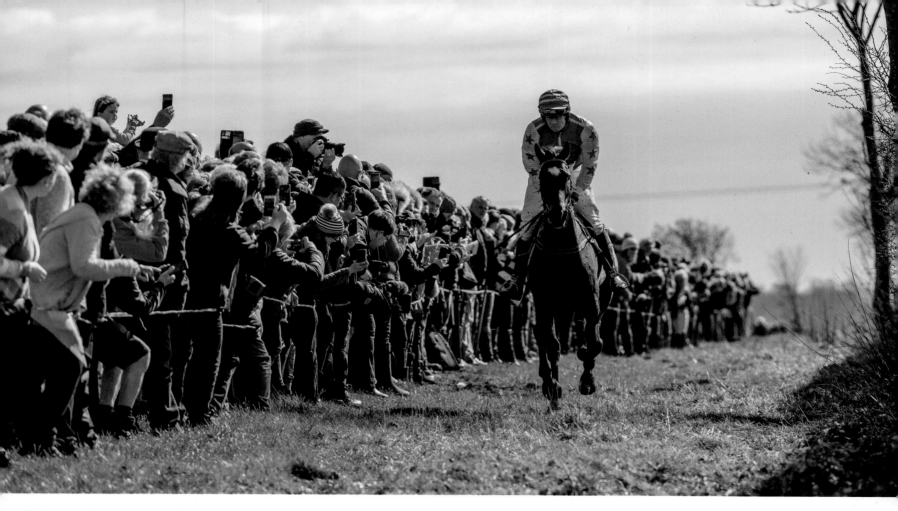

Kiplingcotes horse race

Sunflower

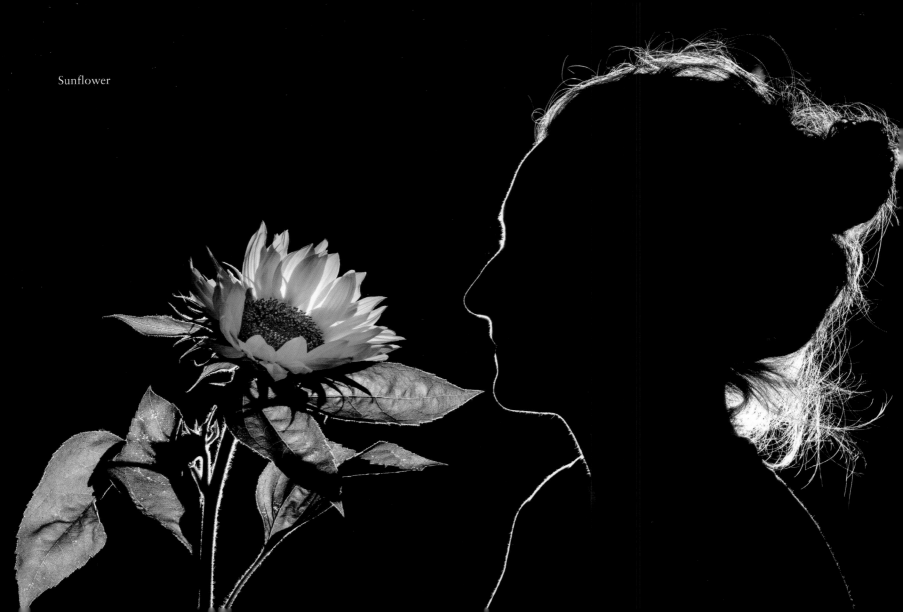

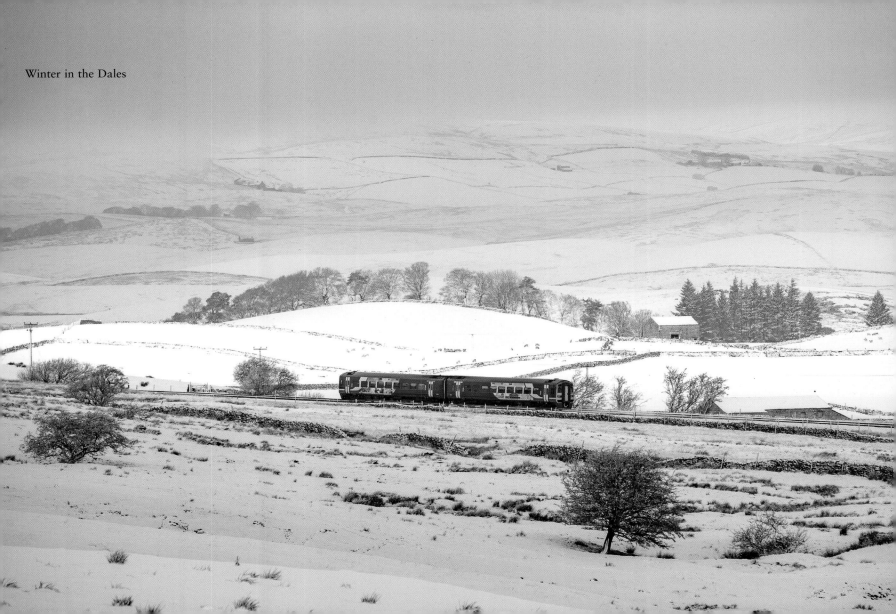

Winter in the Dales

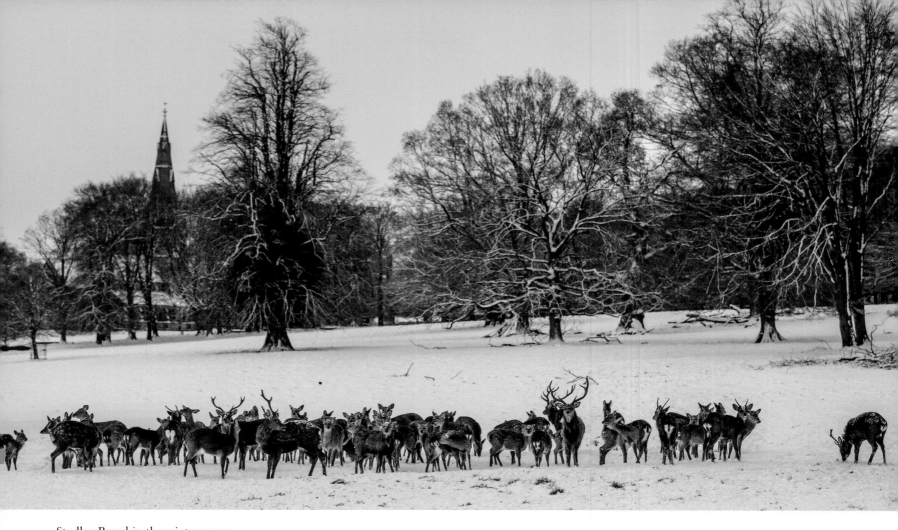

Studley Royal in the winter snow

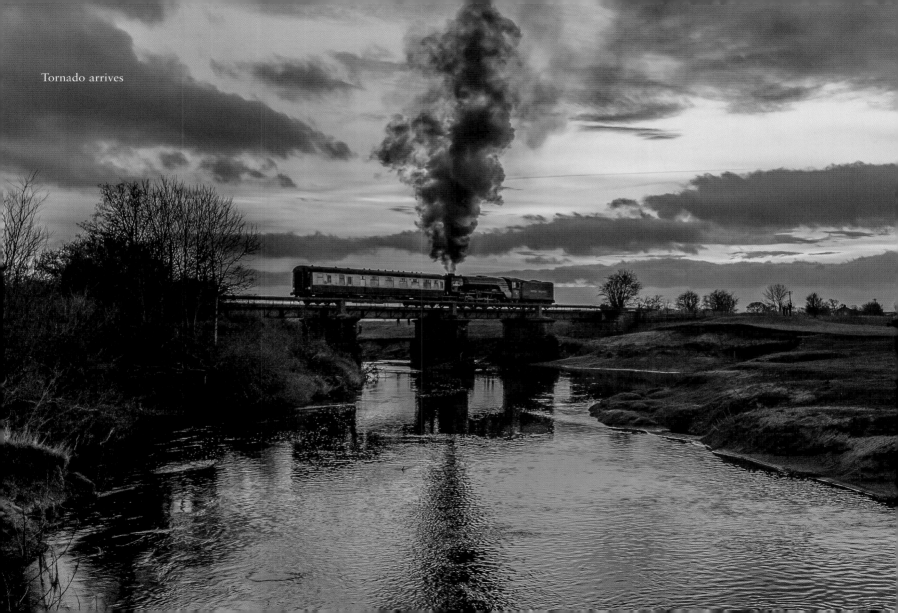

Tornado arrives

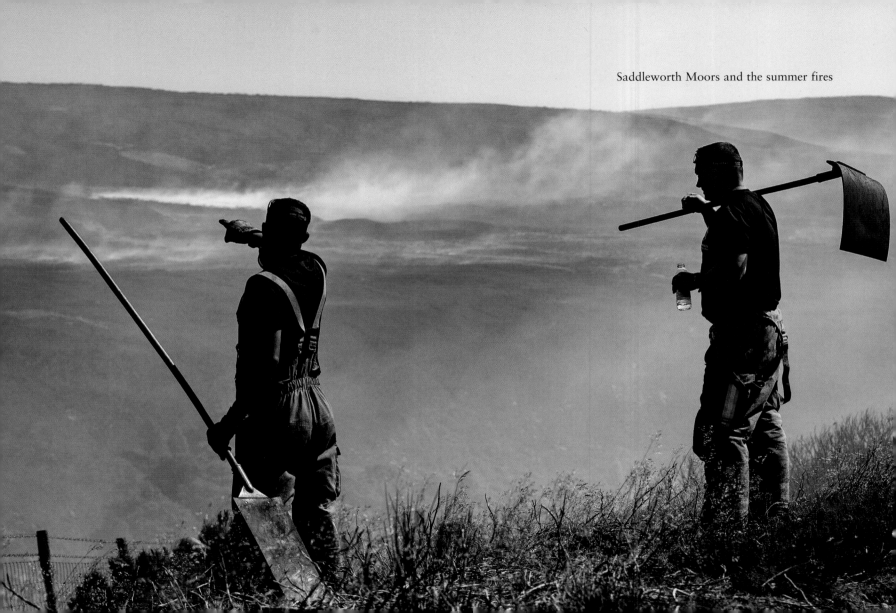

Saddleworth Moors and the summer fires

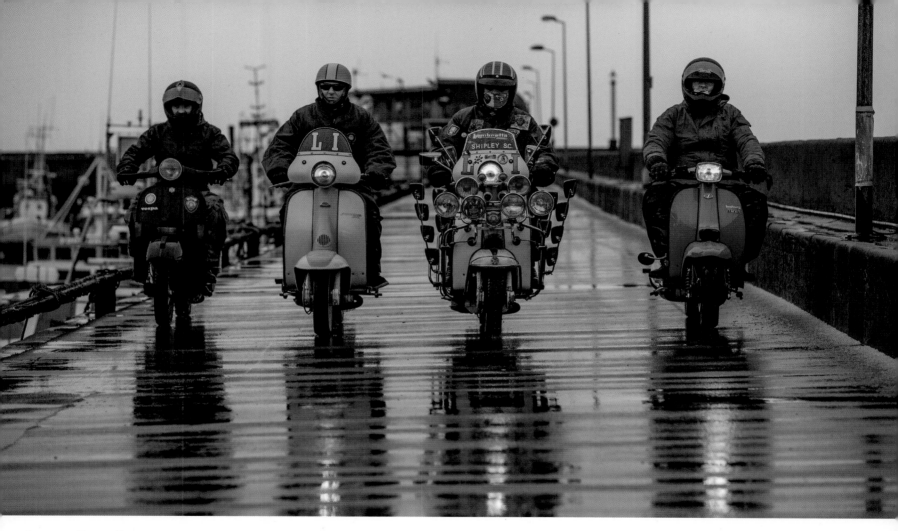

Scooter rally, Bridlington

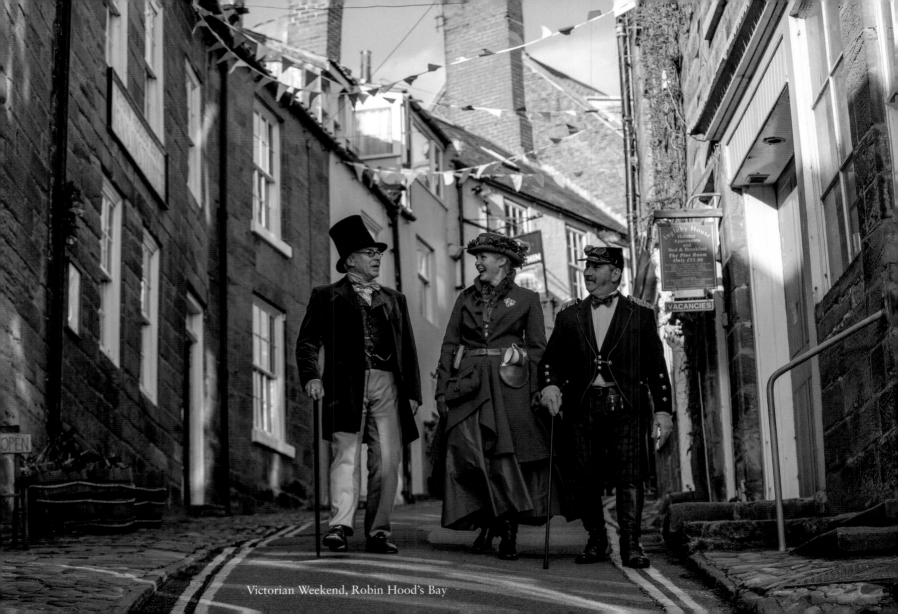

Victorian Weekend, Robin Hood's Bay

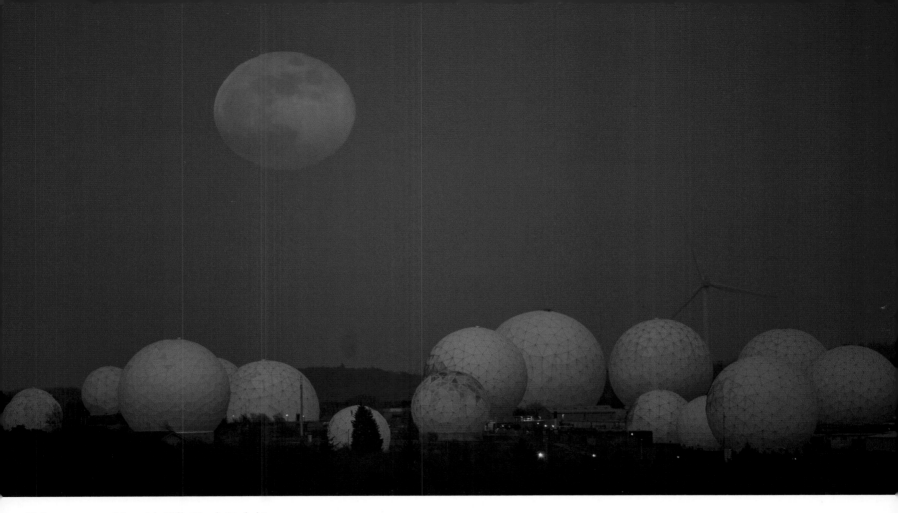

Pink moon over Menwith Hill, North Yorkshire

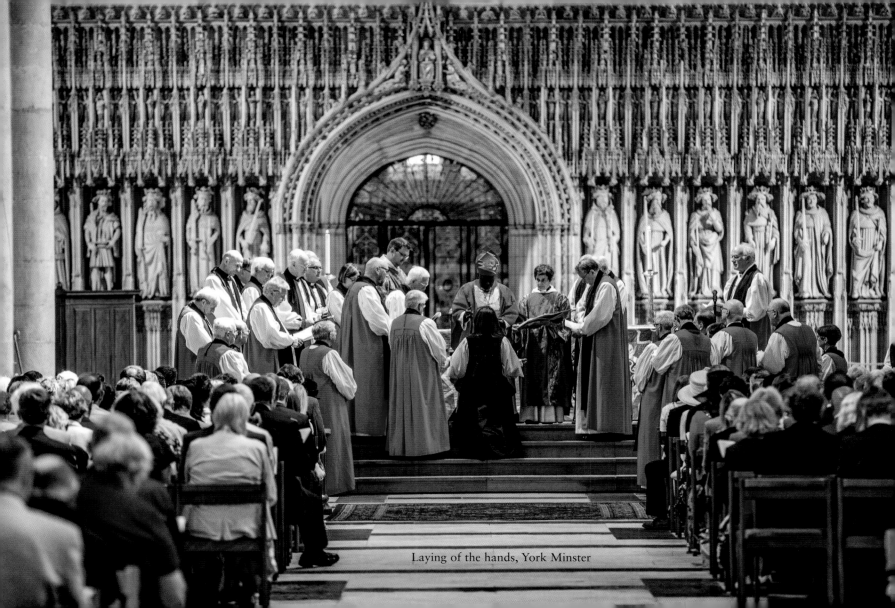

Laying of the hands, York Minster

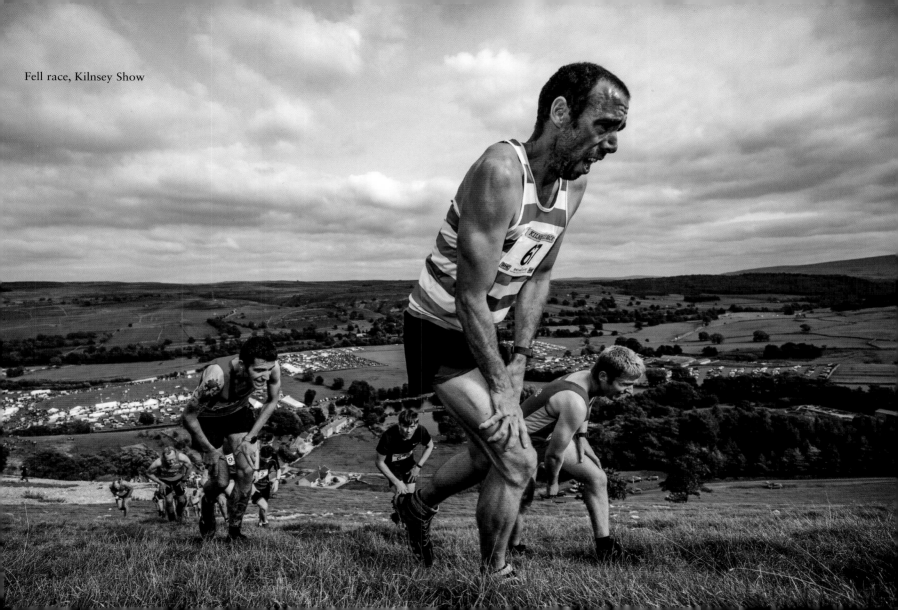

Fell race, Kilnsey Show

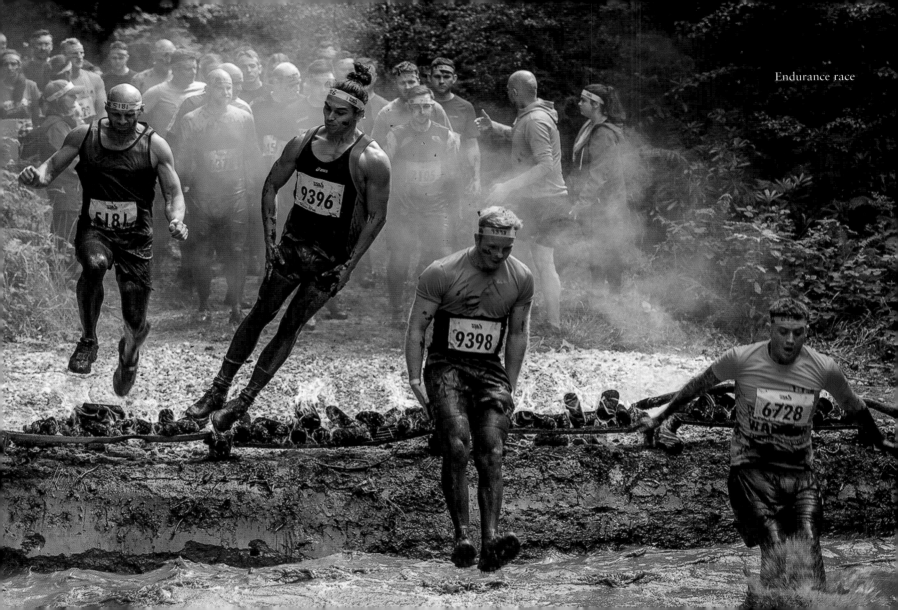

Endurance race

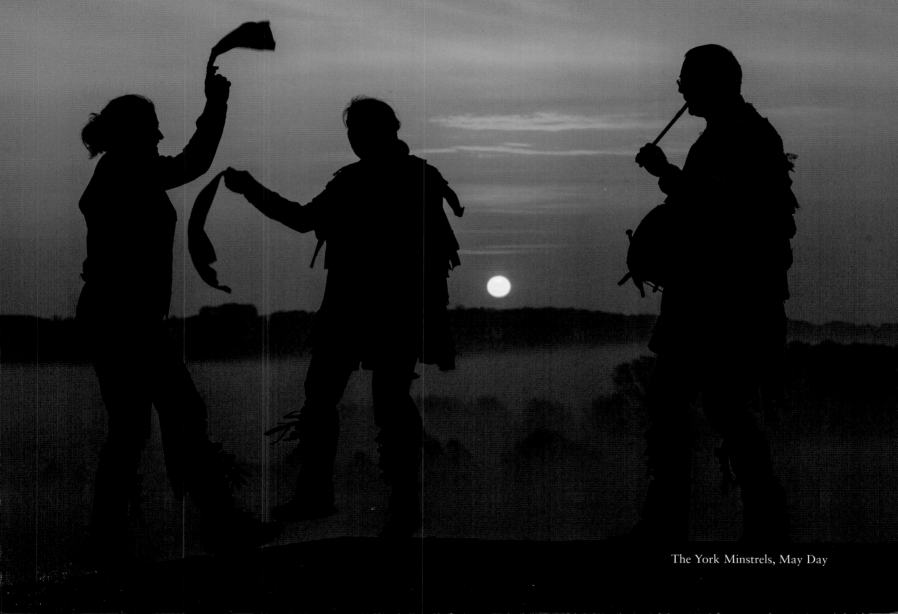

The York Minstrels, May Day

RHS Harlow Carr

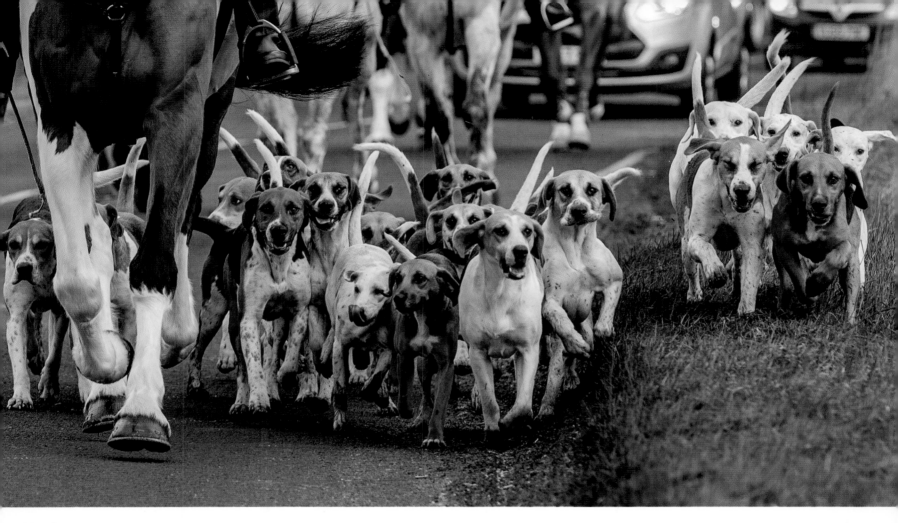

Top dogs

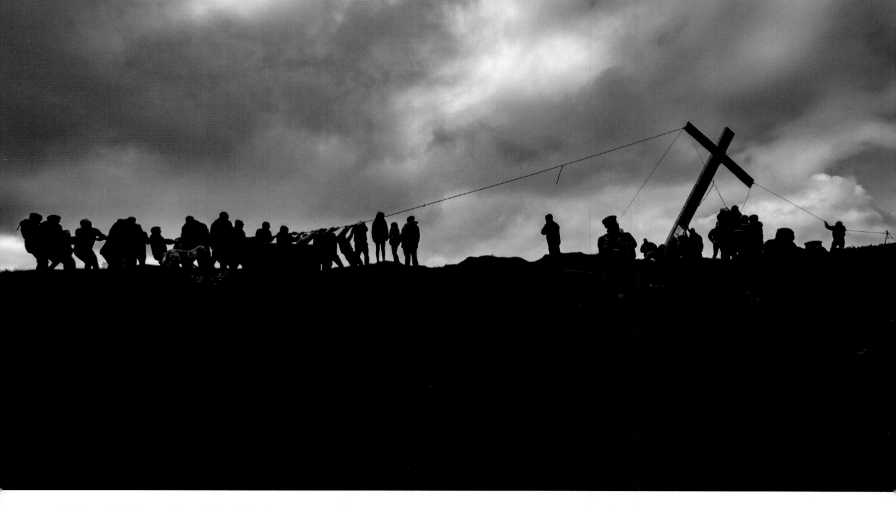

Raising of the Easter Cross, Otley Chevin

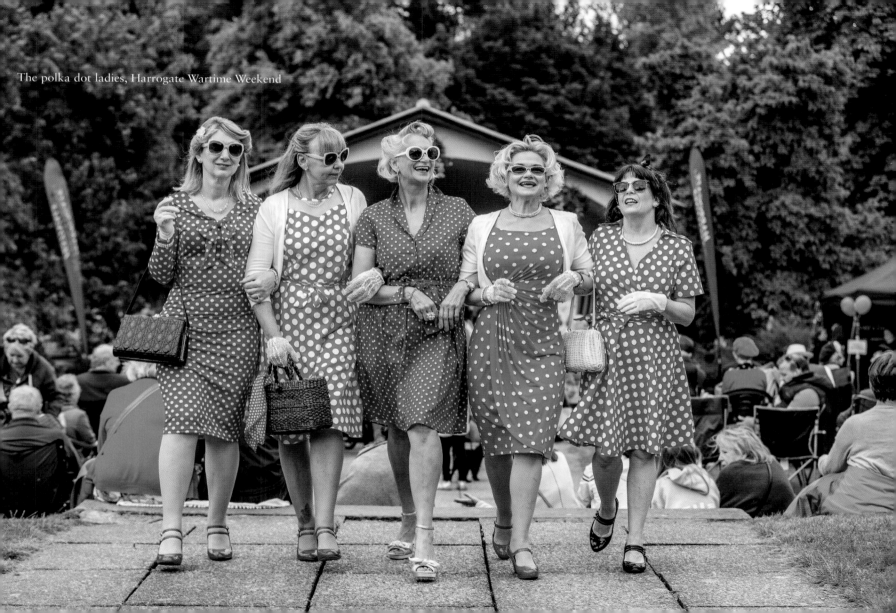

The polka dot ladies, Harrogate Wartime Weekend

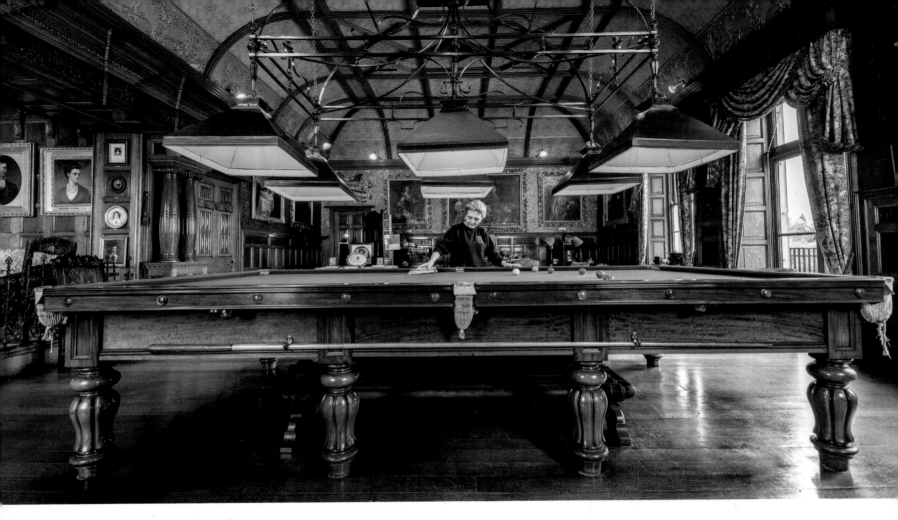

Winter maintenance, Newby Hall

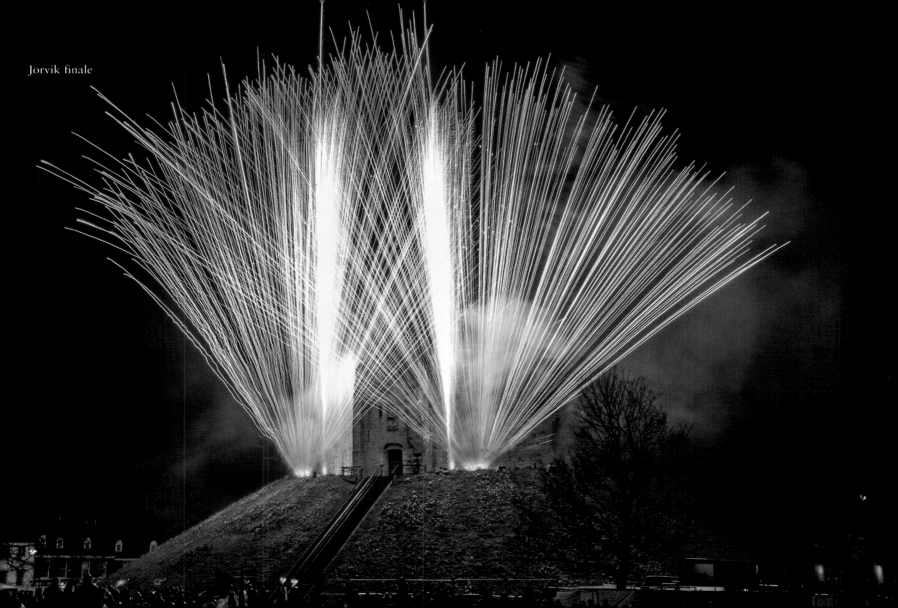

Jorvik finale

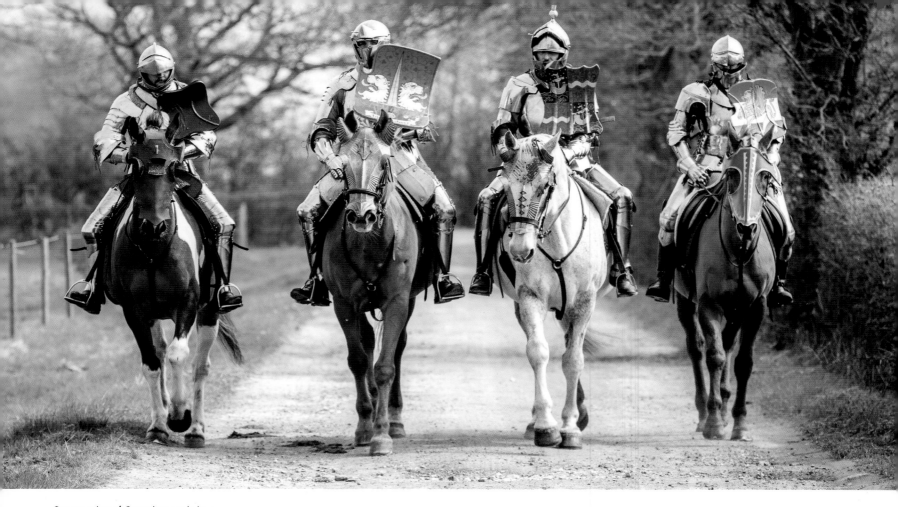

International Jousting training

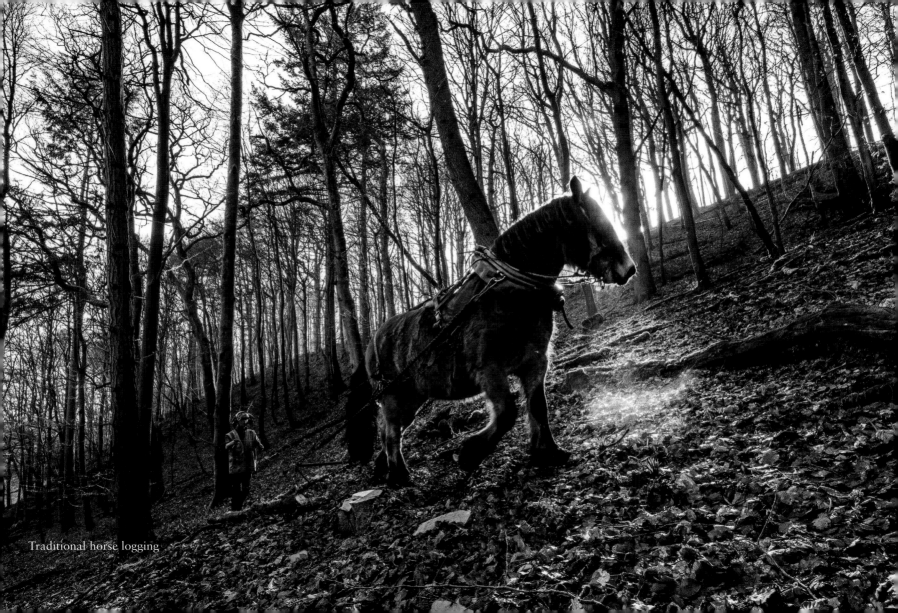

Traditional horse logging

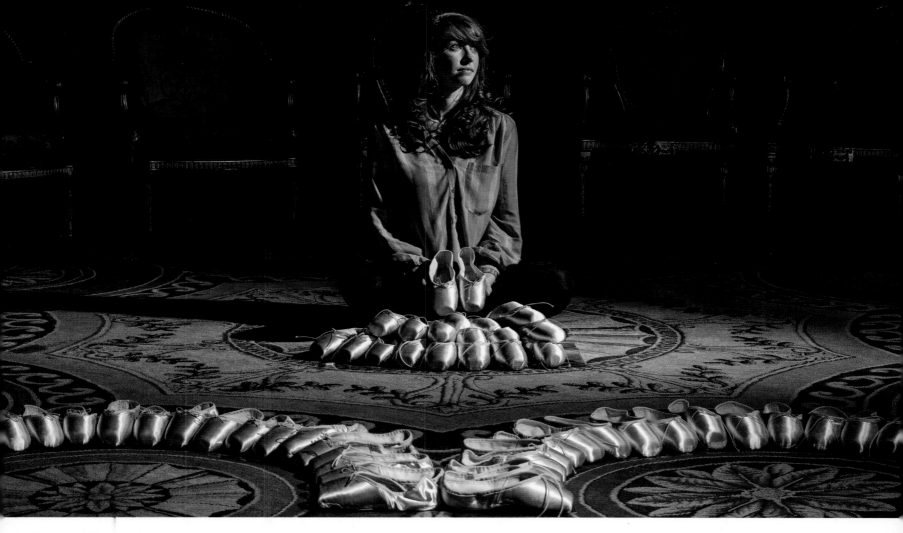

Harewood House

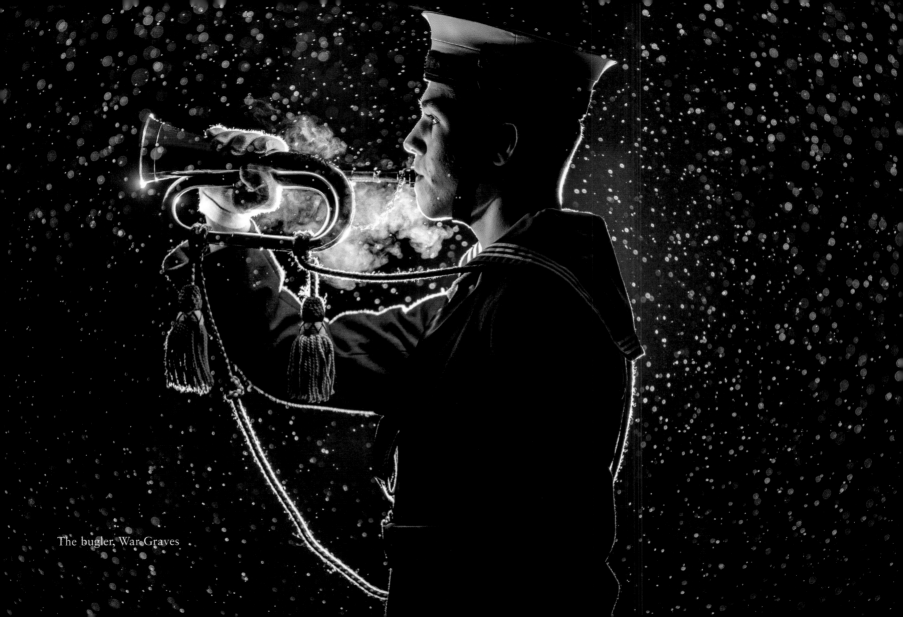

The bugler, War Graves

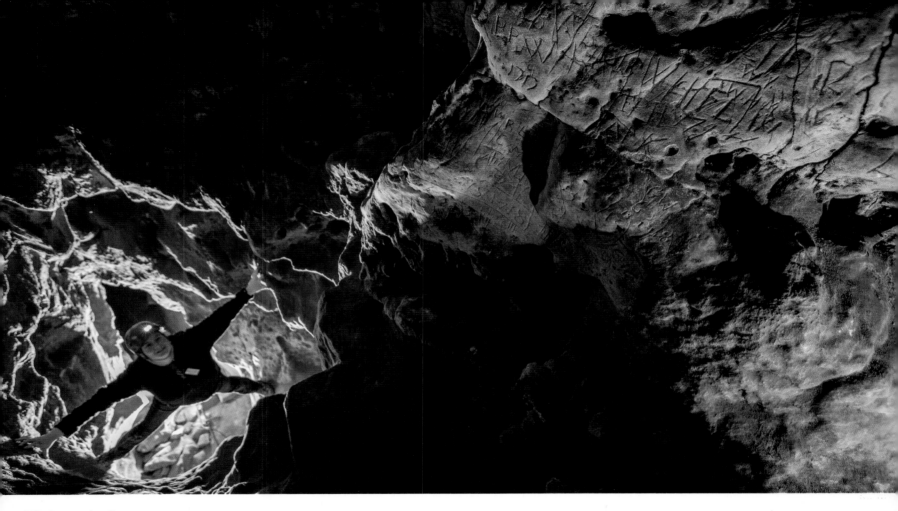

Witches marks discovery

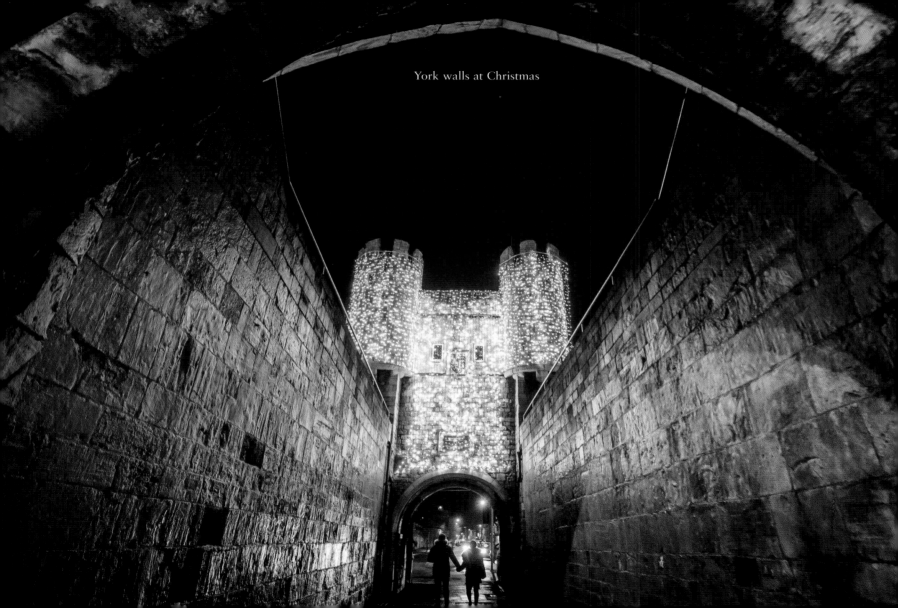

York walls at Christmas

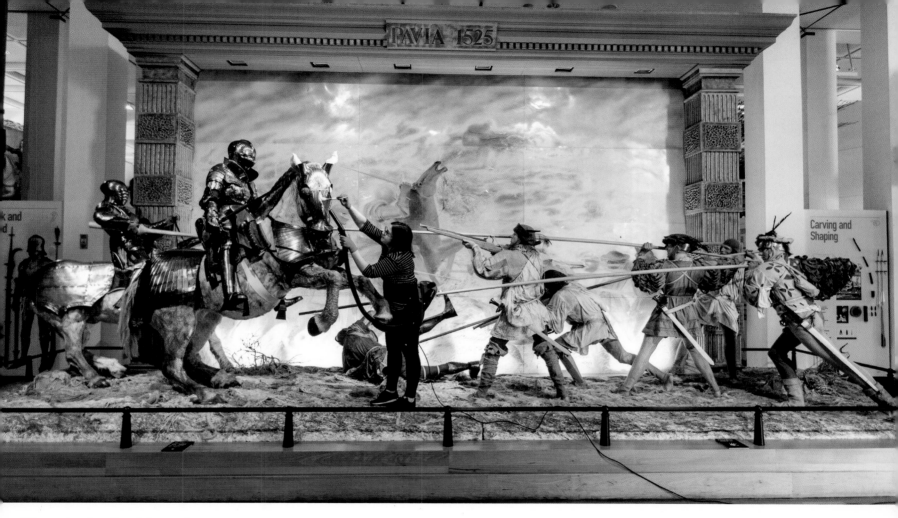

Winter cleaning, Royal Armouries

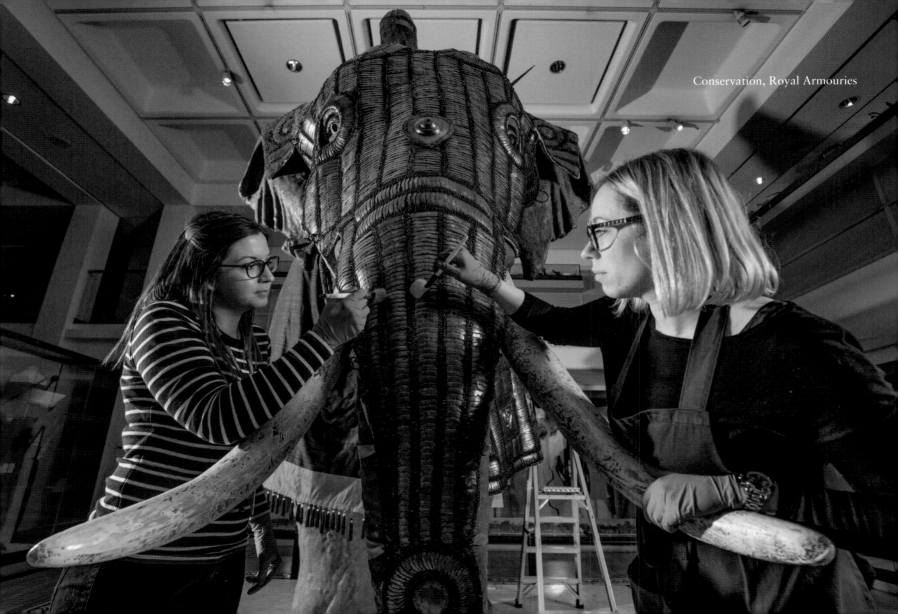

Conservation, Royal Armouries

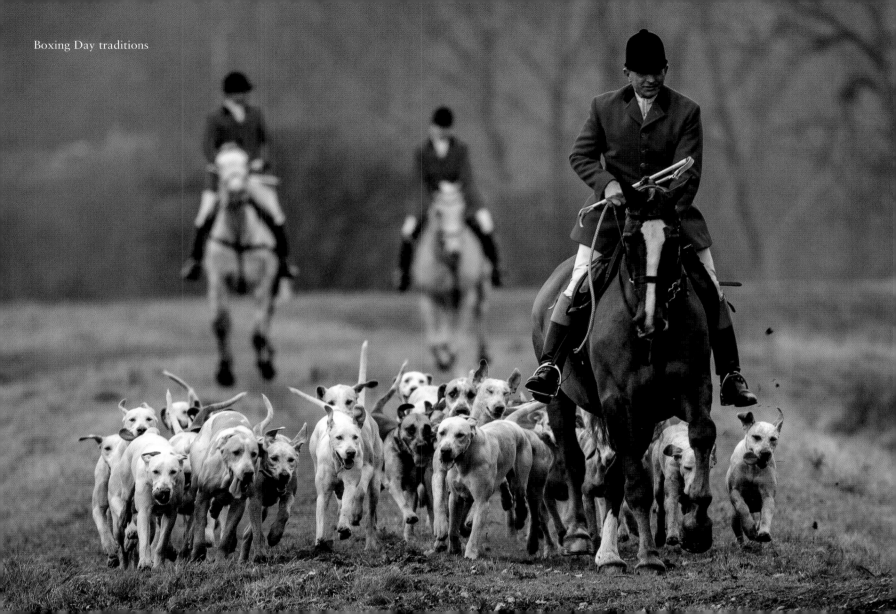

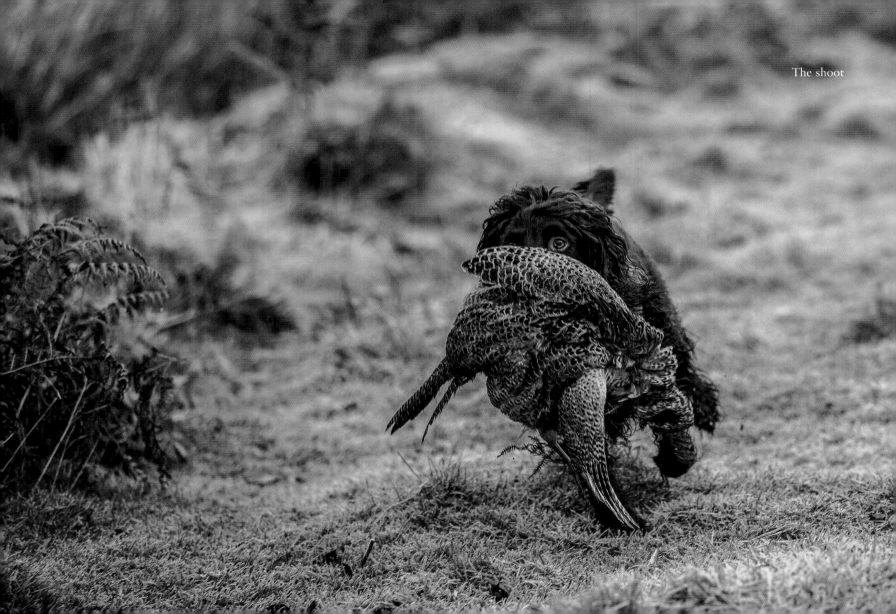

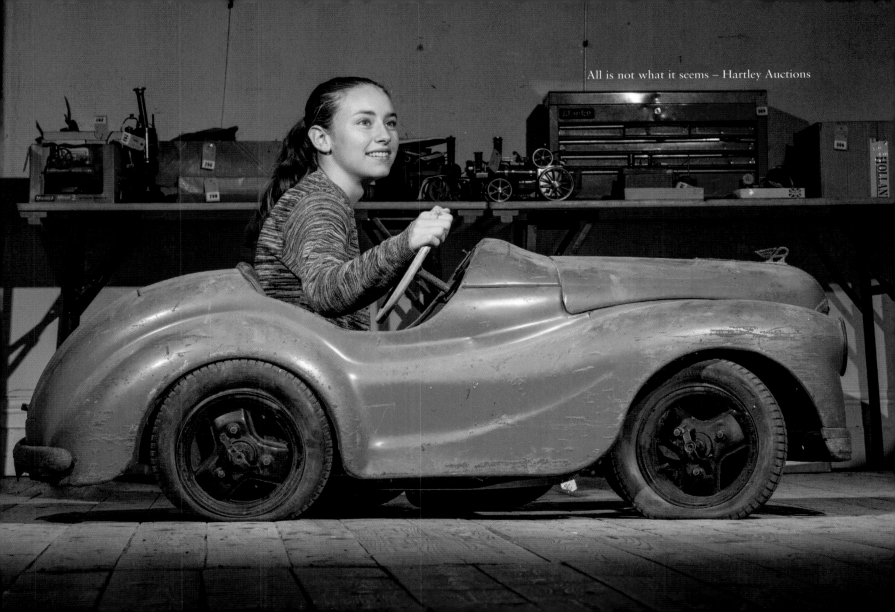

All is not what it seems – Hartley Auctions

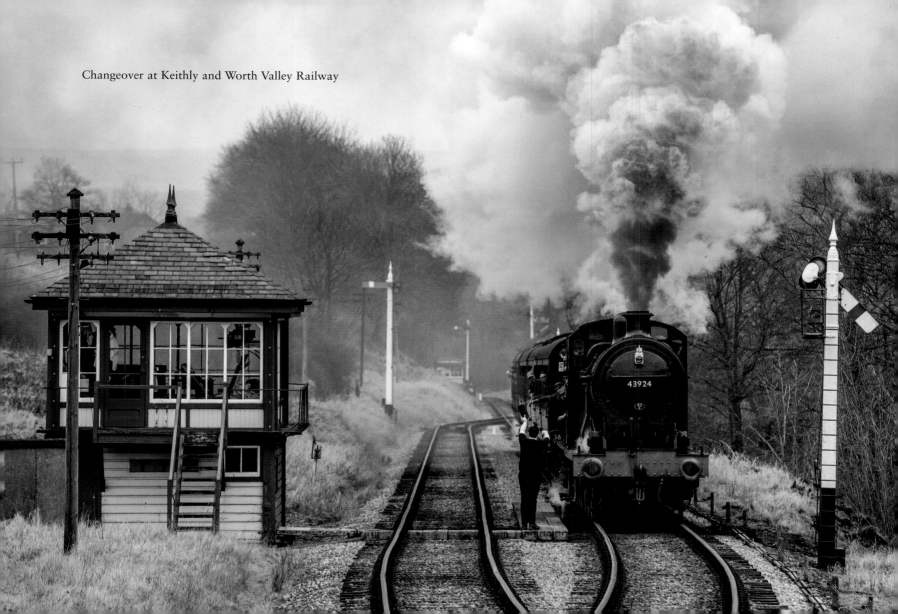

Changeover at Keithly and Worth Valley Railway

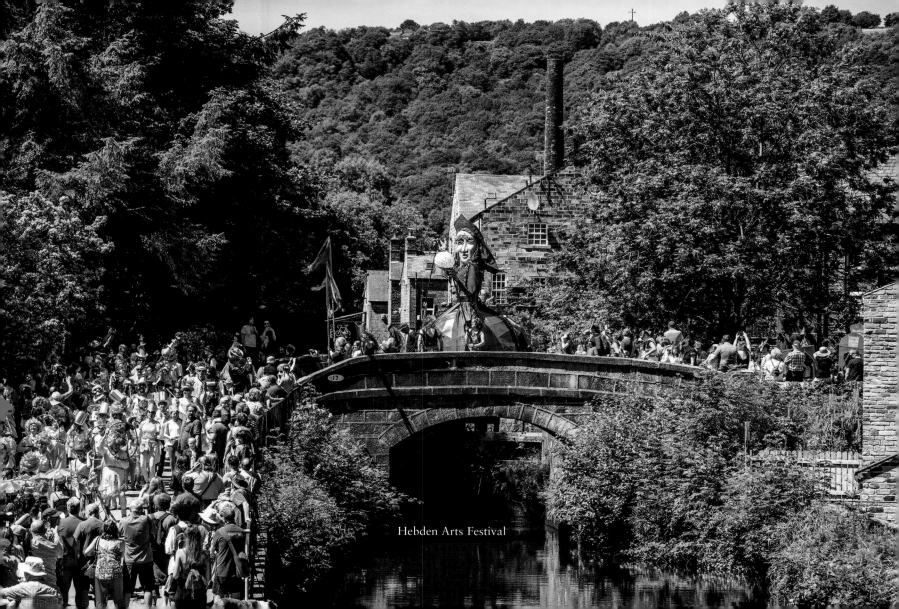

Hebden Arts Festival

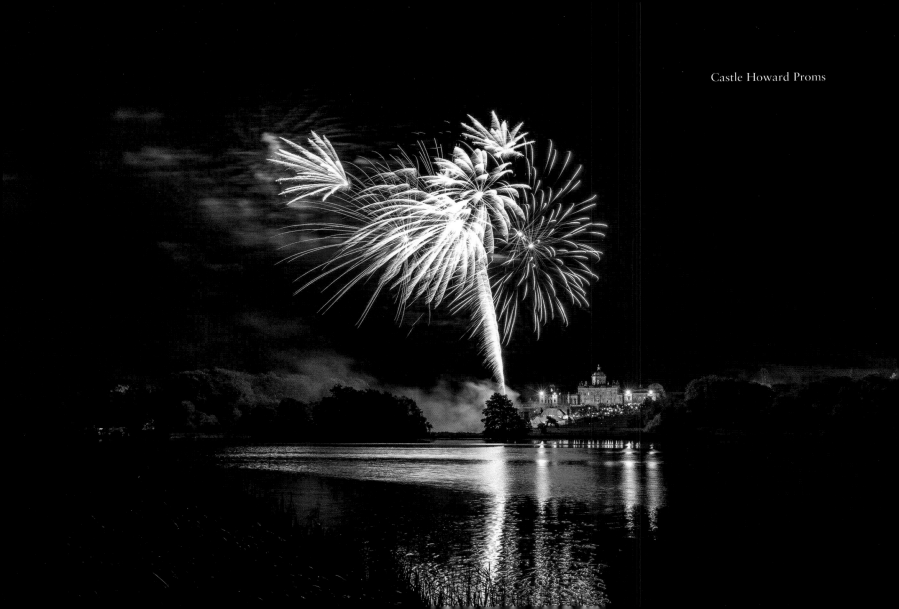

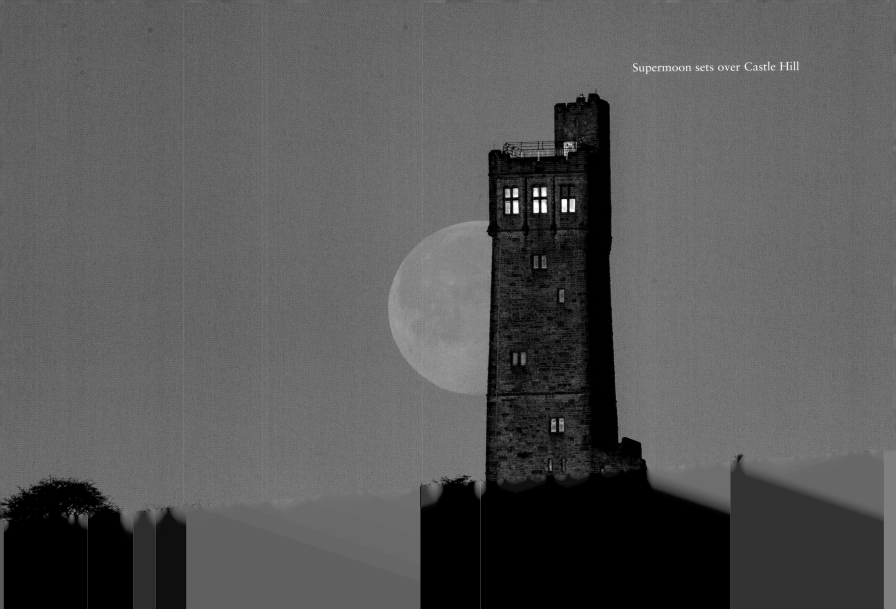

Supermoon sets over Castle Hill

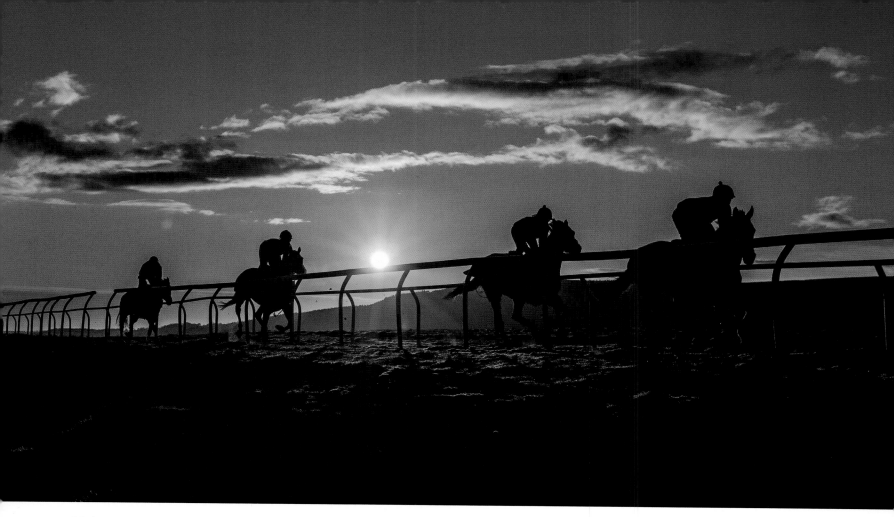

Middleham racehorses

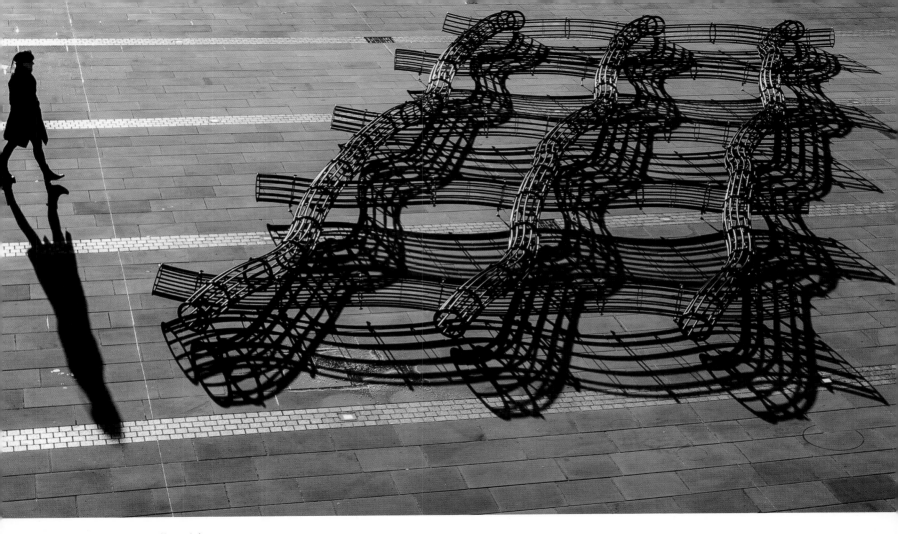

Art installation, Piece Hall, Halifax

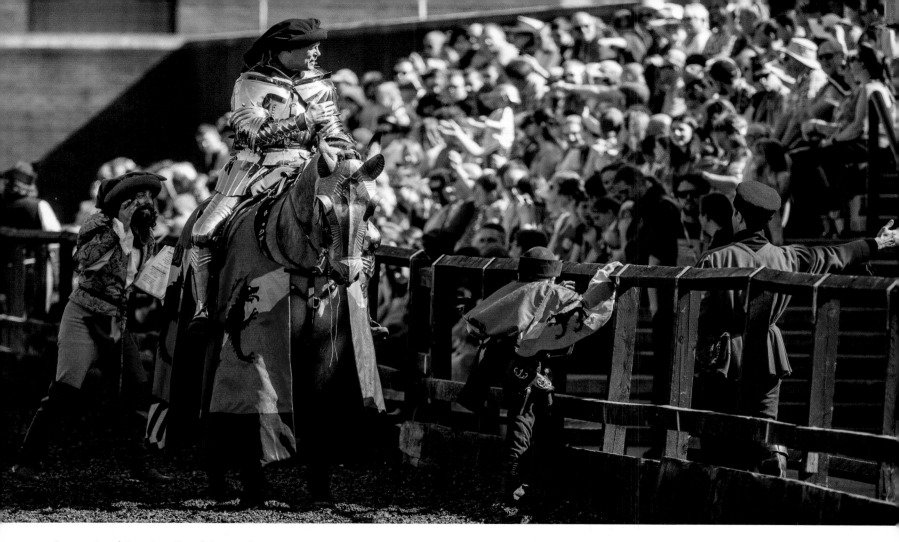

International Jousting, Royal Armouries

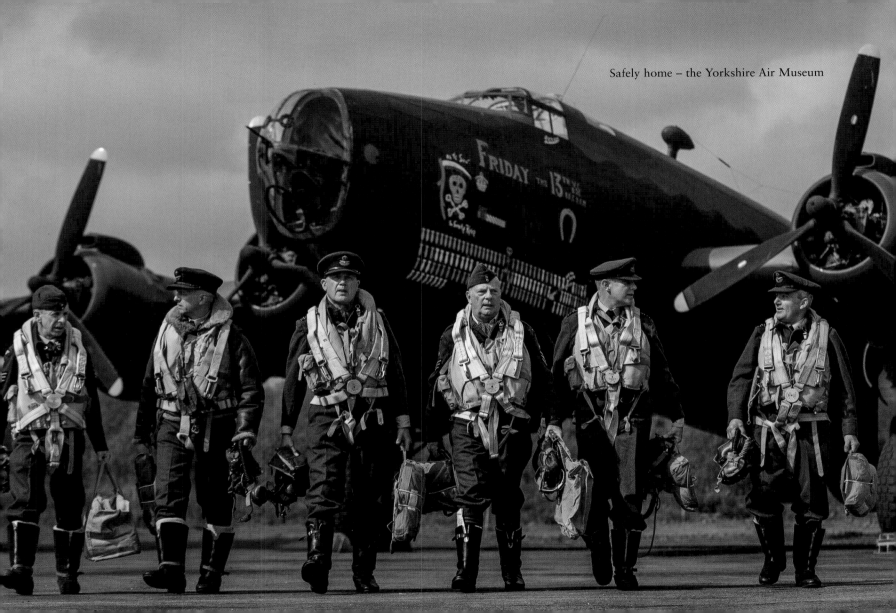

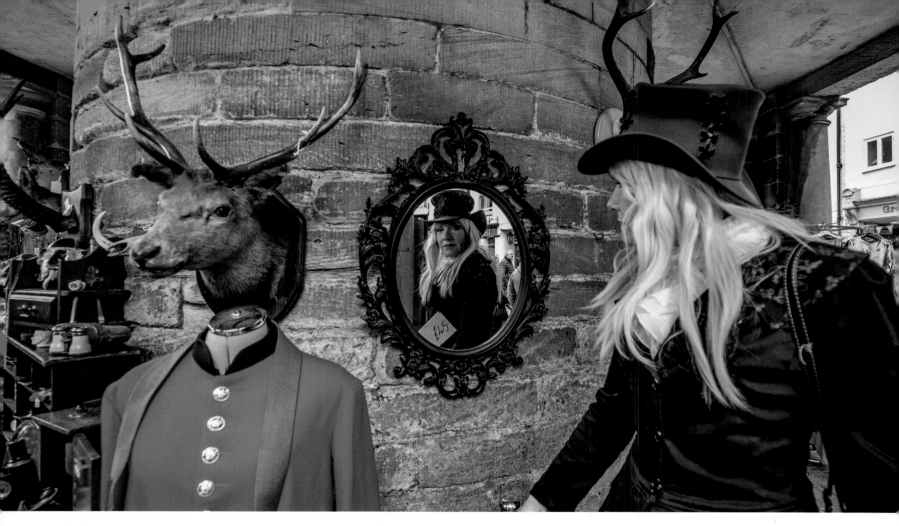

Whitby Goth Festival

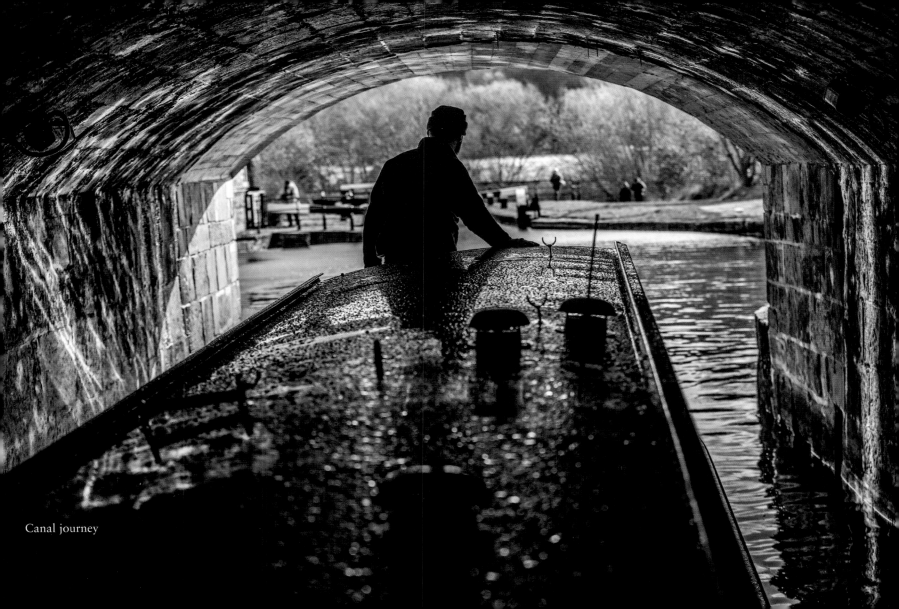

Canal journey

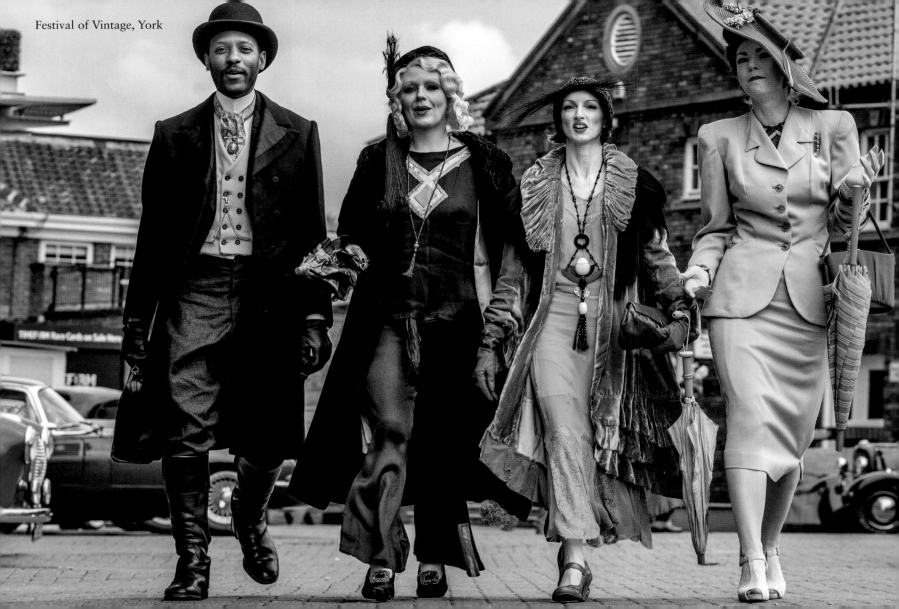

Festival of Vintage, York

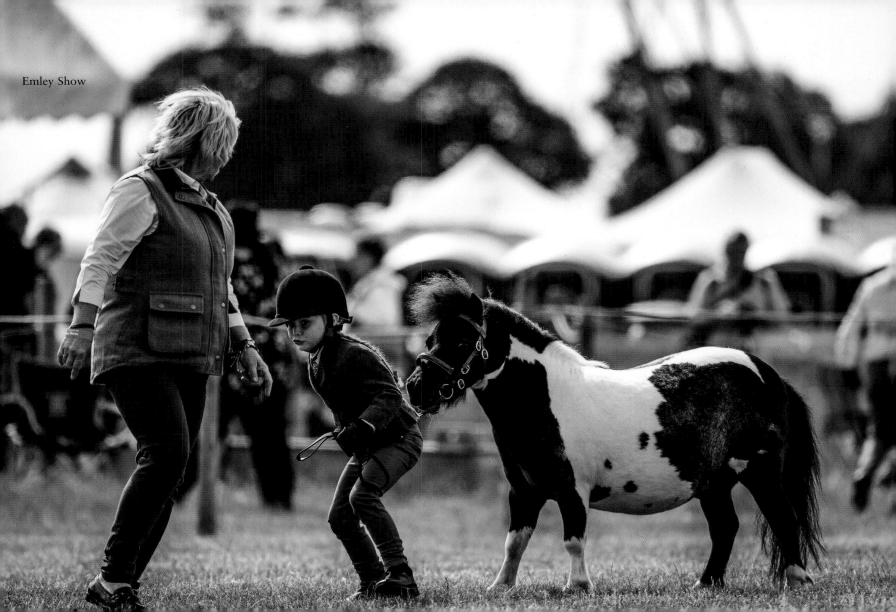

Emley Show

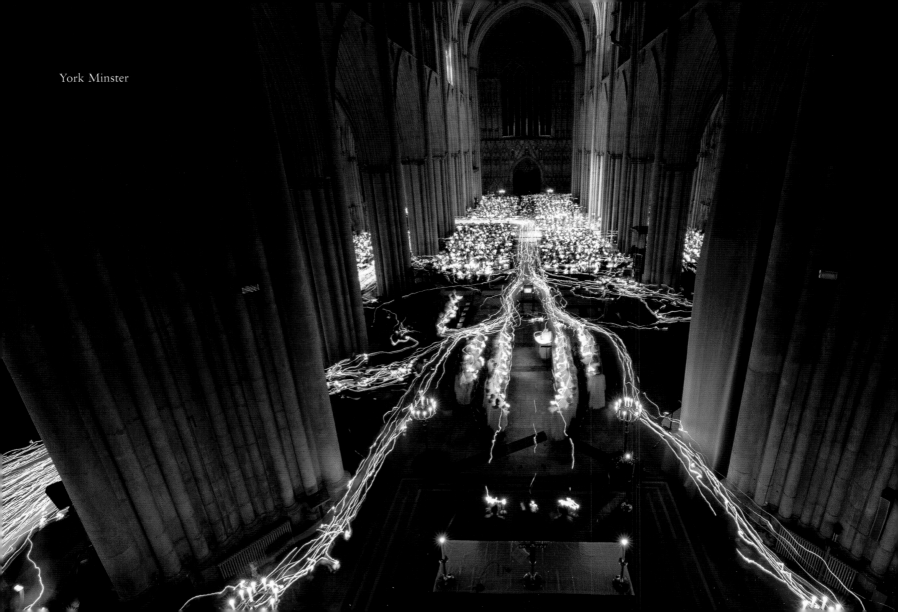

York Minster

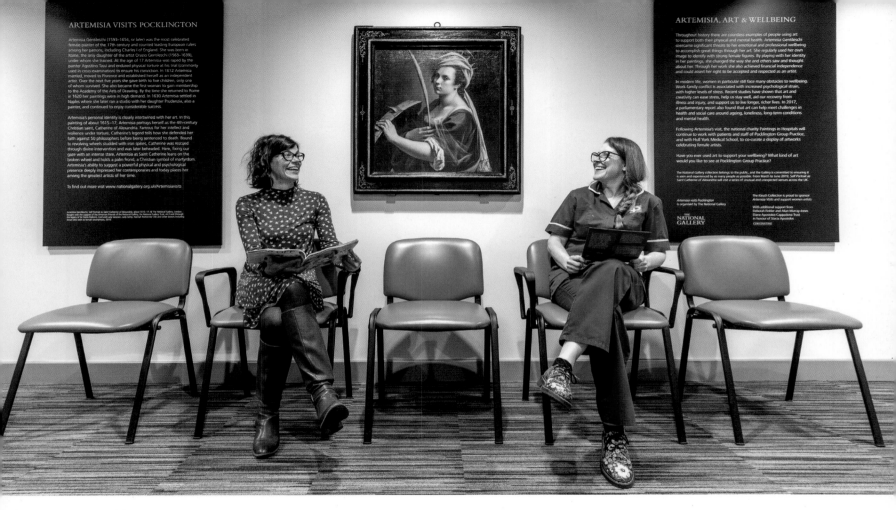

ARTEMISIA VISITS POCKLINGTON

Artemisia Gentileschi (1593–1654, or later) was the most celebrated female painter of the 17th century and counted leading European rulers among her patrons, including Charles I of England. She was born in Rome, the only daughter of the artist Orazio Gentileschi (1563–1639), under whom she trained. At the age of 17 Artemisia was raped by the painter Agostino Tassi and endured physical torture at his trial (commonly used in cross-examination) to ensure his conviction. In 1612 Artemisia married, moved to Florence and established herself as an independent artist. Over the next five years she gave birth to five children, only one of whom survived. She also became the first woman to gain membership to the Academy of the Arts of Drawing. By the time she returned to Rome in 1620 her paintings were in high demand. In 1630 Artemisia settled in Naples where she later ran a studio with her daughter Prudenzia, also a painter, and continued to enjoy considerable success.

Artemisia's personal identity is closely intertwined with her art. In this painting of about 1615–17, Artemisia portrays herself as the 4th-century Christian saint, Catherine of Alexandria. Famous for her intellect and resilience under torture, Catherine's legend tells how she defended her faith against 50 philosophers before being sentenced to death. Bound to revolving wheels studded with iron spikes, Catherine was rescued through divine intervention and was later beheaded. Here, fixing our gaze with an intense stare, Artemisia as Saint Catherine leans on the broken wheel and holds a palm frond, a Christian symbol of martyrdom. Artemisia's ability to suggest a powerful physical and psychological presence deeply impressed her contemporaries and today places her among the greatest artists of her time.

To find out more visit www.nationalgallery.org.uk/Artemisiavisits

ARTEMISIA, ART & WELLBEING

Throughout history there are countless examples of people using art to support both their physical and mental health. Artemisia Gentileschi overcame significant threats to her emotional and professional wellbeing to accomplish great things through her art. She regularly used her own image to identify with strong female figures. By playing with her identity in her paintings, she changed the way she and others saw and thought about her. Through her work she also achieved financial independence and could assert her right to be accepted and respected as an artist.

In modern life, women in particular still face many obstacles to wellbeing. Work-family conflict is associated with increased psychological strain, with higher levels of stress. Recent studies have shown that art and creativity can ease stress, help us to stay well, aid our recovery from illness and injury, and support us to live longer, richer lives. In 2017, a parliamentary report also found that art can help meet challenges in health and social care around ageing, loneliness, long-term conditions and mental health.

Following Artemisia's visit, the national charity Paintings in Hospitals will continue to work with patients and staff of Pocklington Group Practice, and with Hull York Medical School, to co-curate a display of artworks celebrating female artists.

Have you ever used art to support your wellbeing? What kind of art would you like to see at Pocklington Group Practice?

The National Gallery collection belongs to the public, and the Gallery is committed to ensuring it is seen and experienced by as many people as possible. From March to June 2019, Self Portrait as Saint Catherine of Alexandria will visit a series of unusual and unexpected venues across the UK.

Artemisia visits Pocklington is organised by The National Gallery

THE NATIONAL GALLERY

The Klesch Collection is proud to sponsor Artemisia Visits and support women artists

With additional support from Deborah Finkler and Allan Murray-Jones Diane Apostolos-Cappadona Trust In honour of 'Stucia Apostolos.

Art arrives in Pocklington

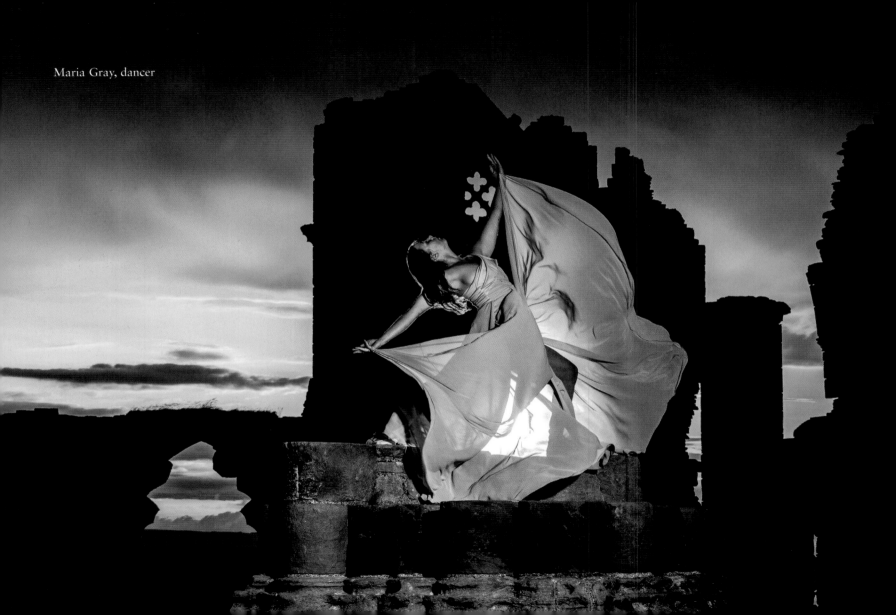

Maria Gray, dancer

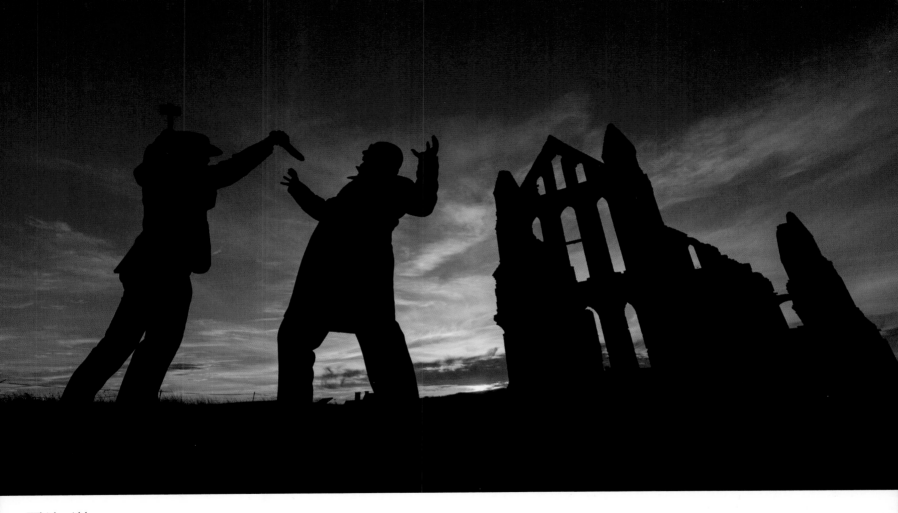

Whitby Abbey

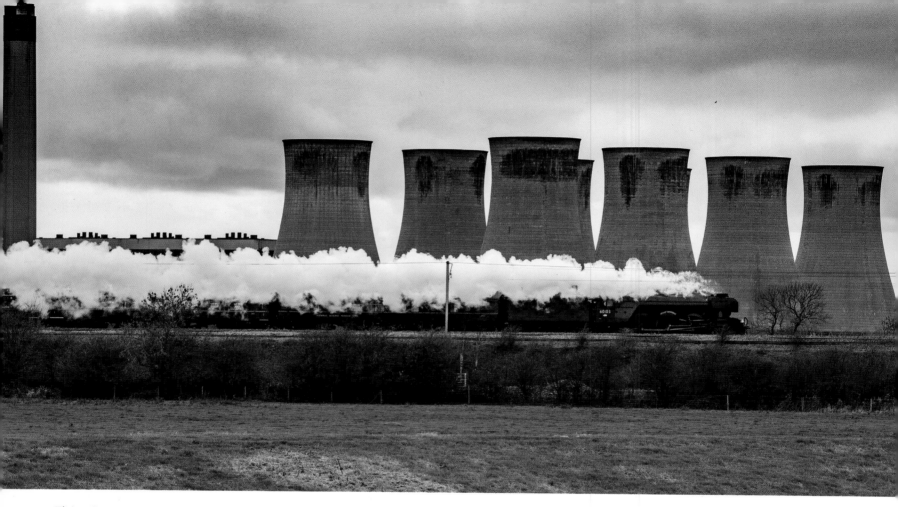

Flying Scotsman

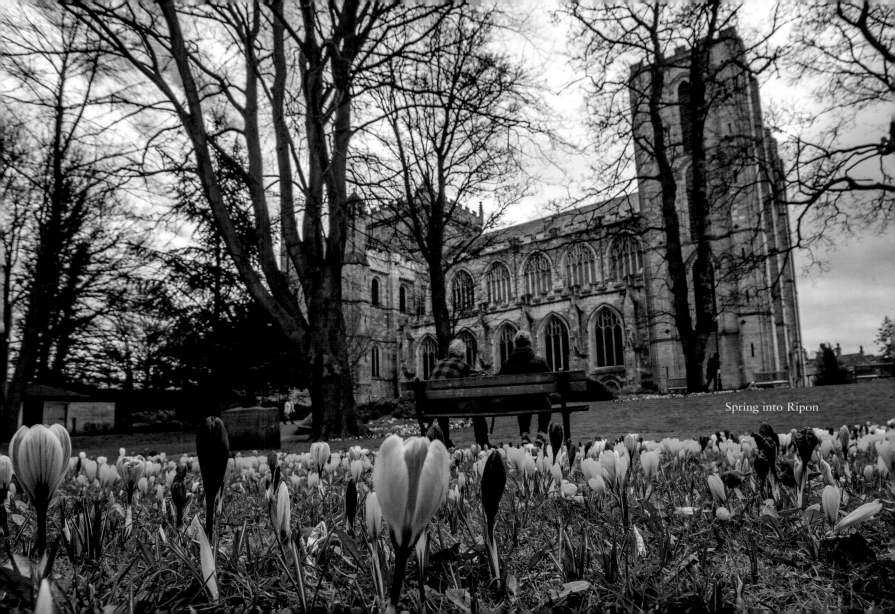

Spring into Ripon

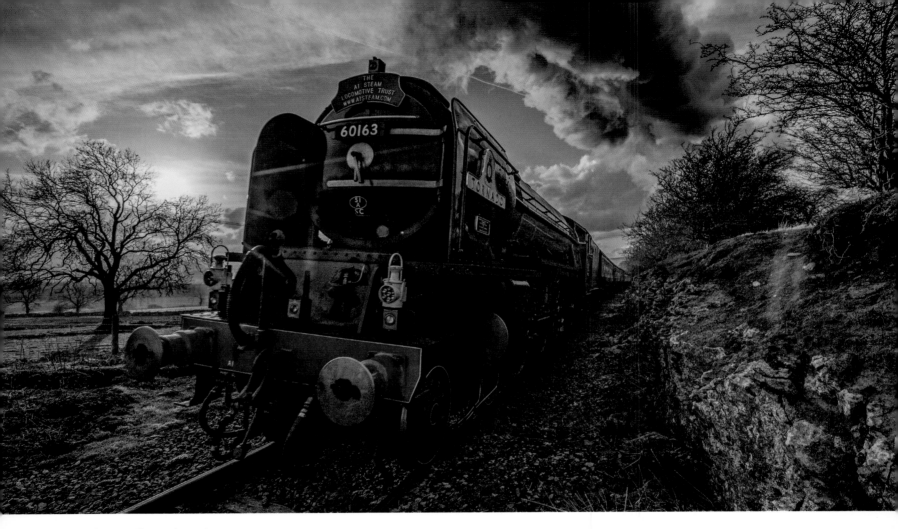

Tornado, Wendley Dale Railway

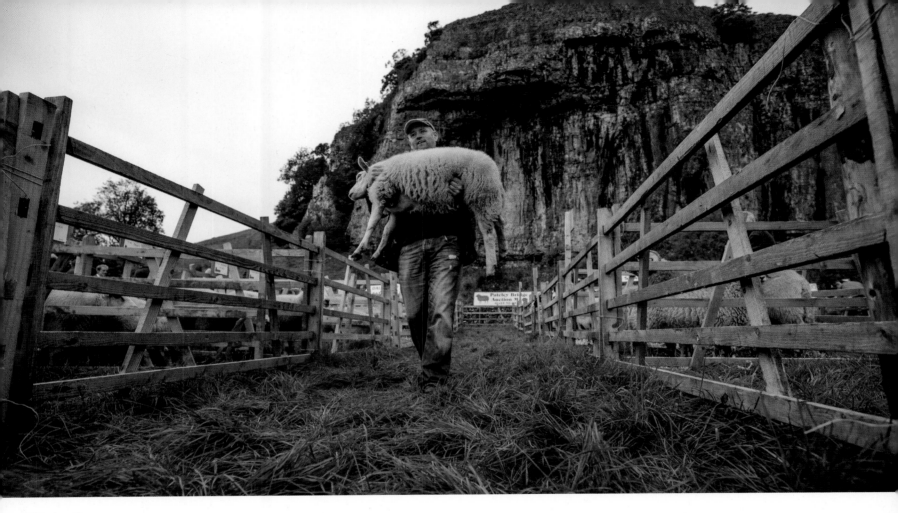

Kilnsley Show

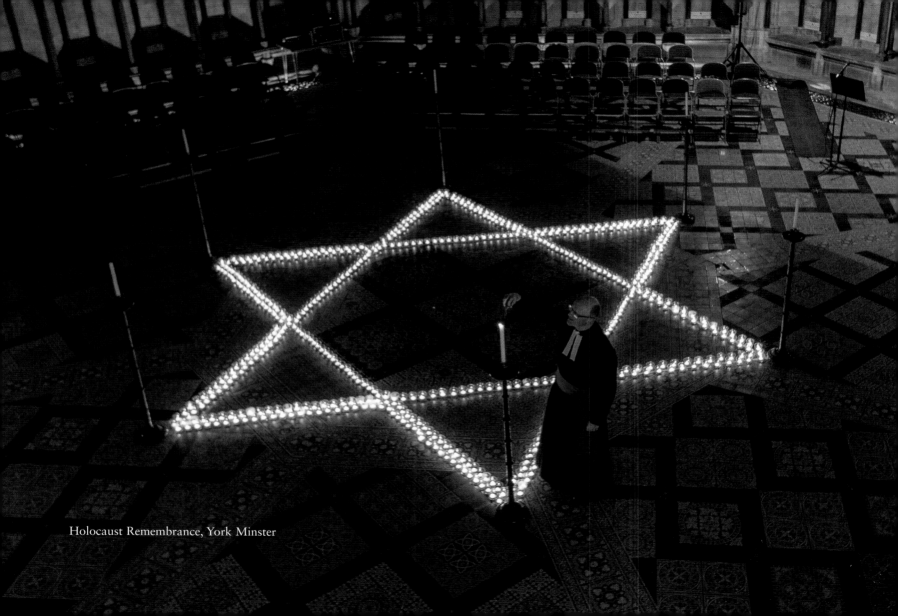

Holocaust Remembrance, York Minster

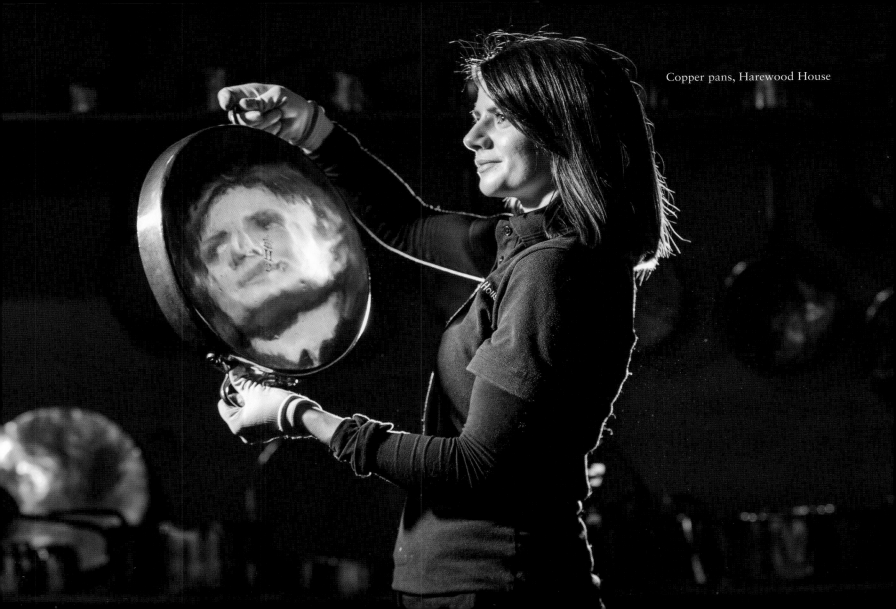

Copper pans, Harewood House

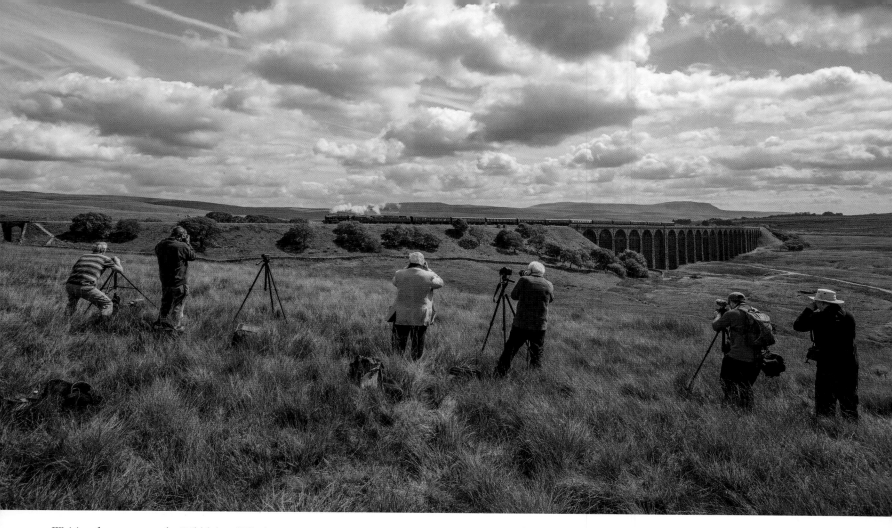

Waiting for steam at the Ribblehead Viaduct

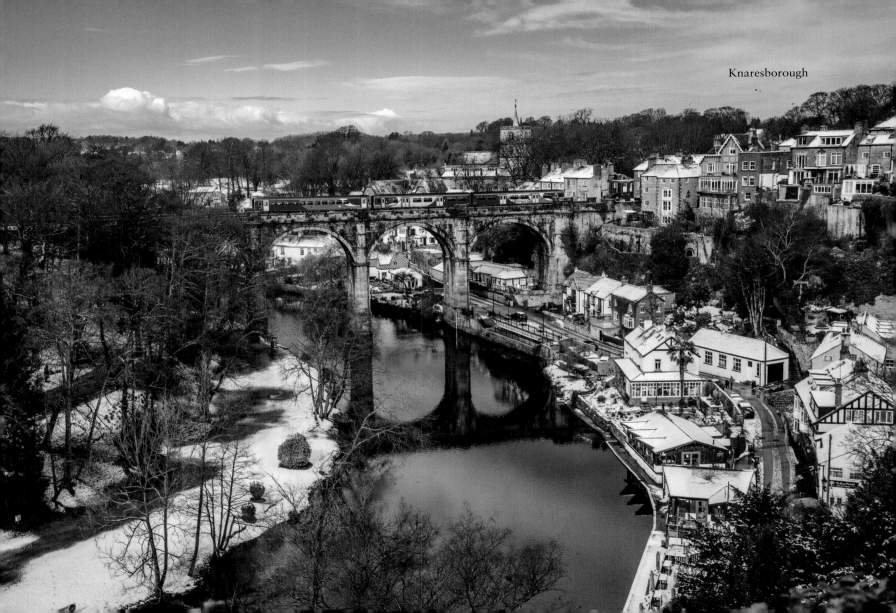

Knaresborough

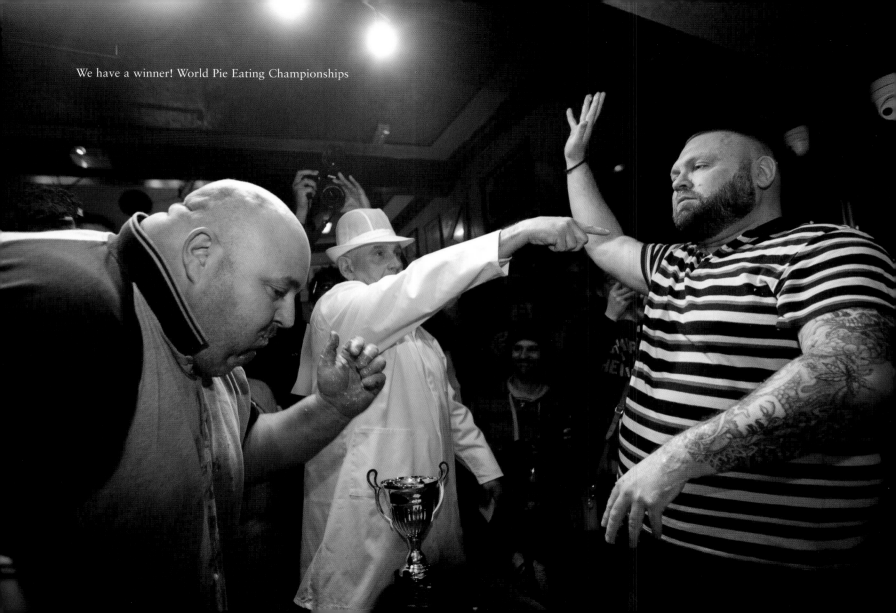

We have a winner! World Pie Eating Championships

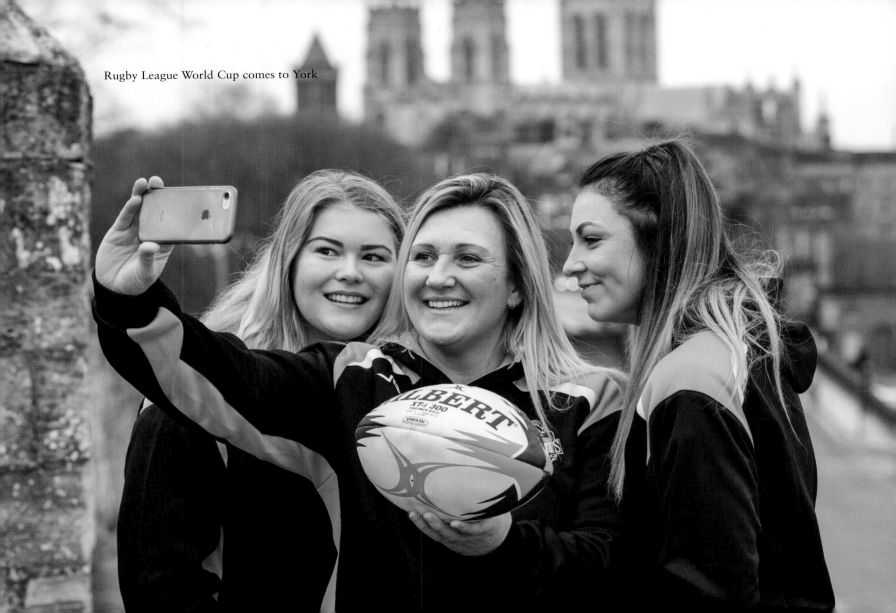

Rugby League World Cup comes to York

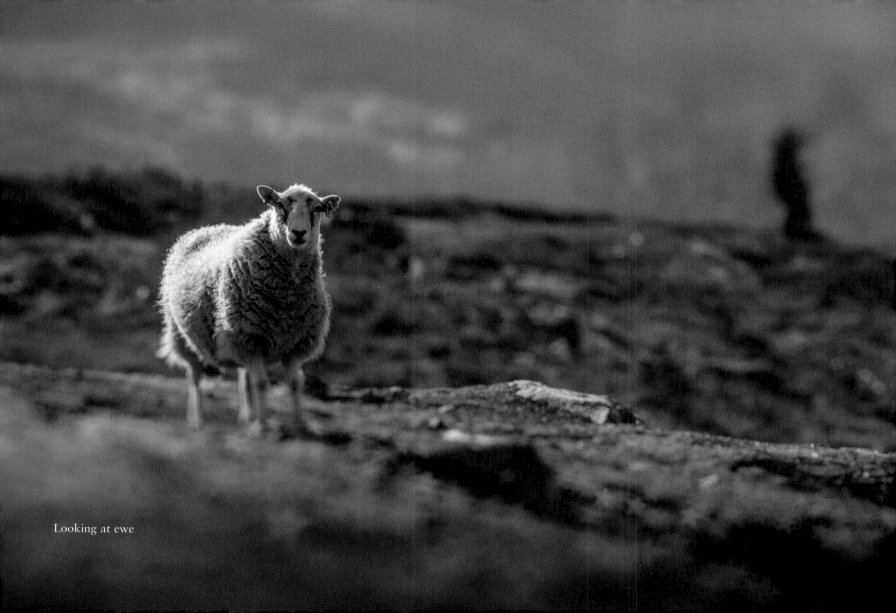

Looking at ewe

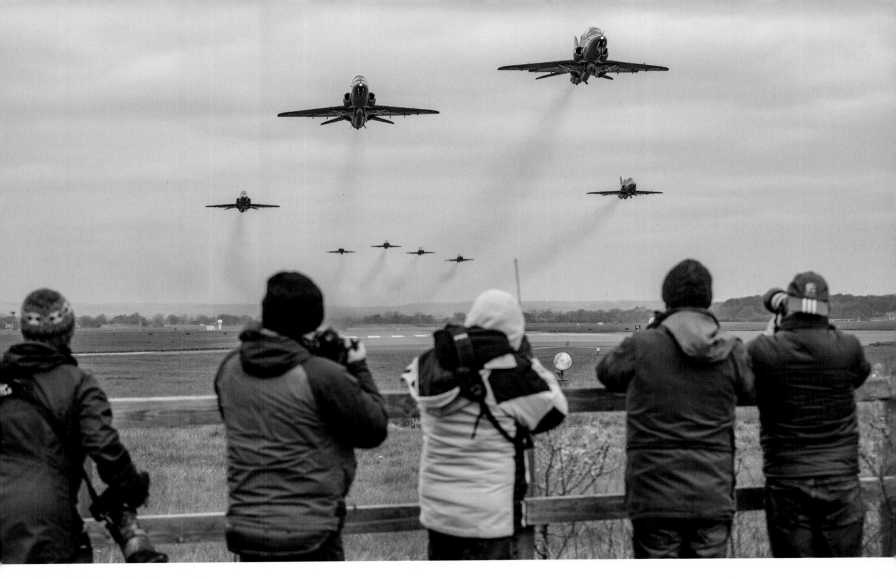

Royal Air Force Red Arrows, Linton

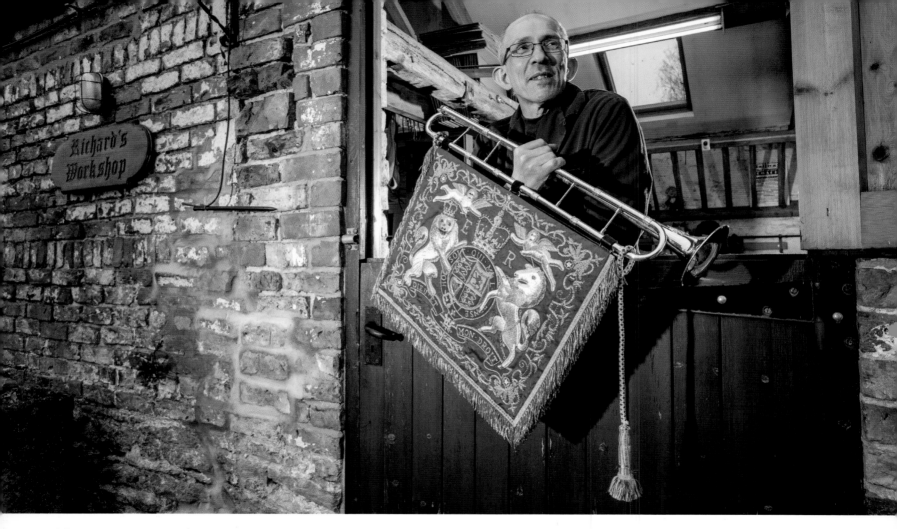

The Queen's trumpet maker

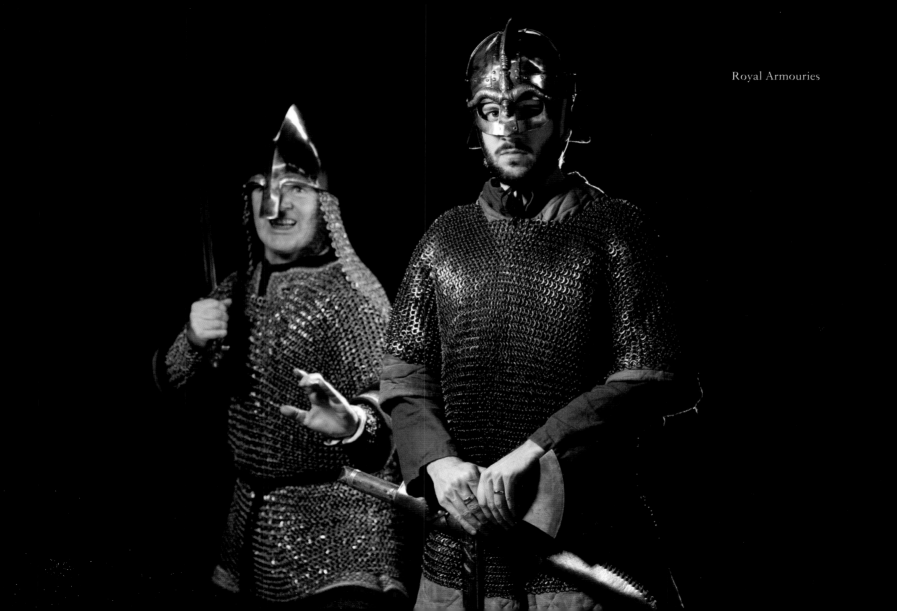

Royal Armouries

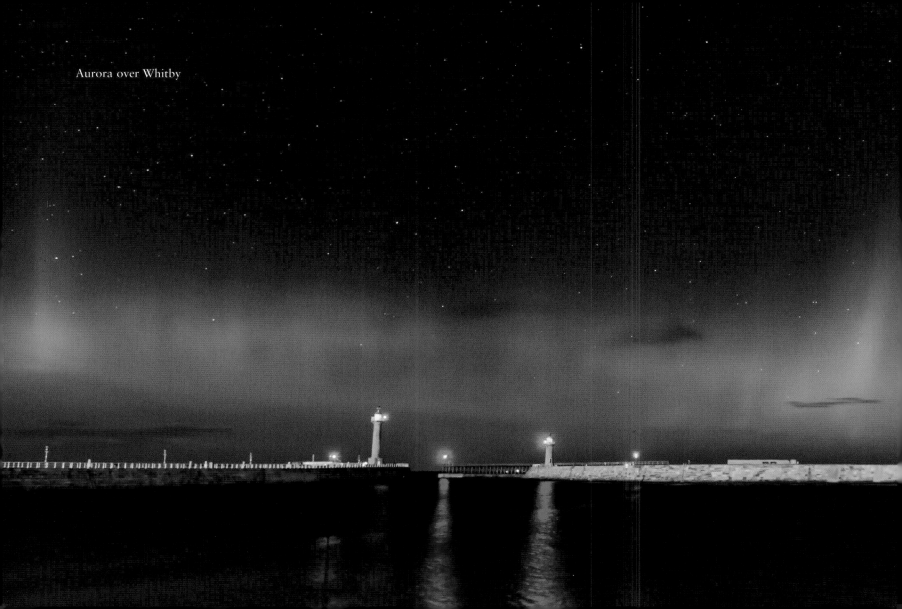

Aurora over Whitby

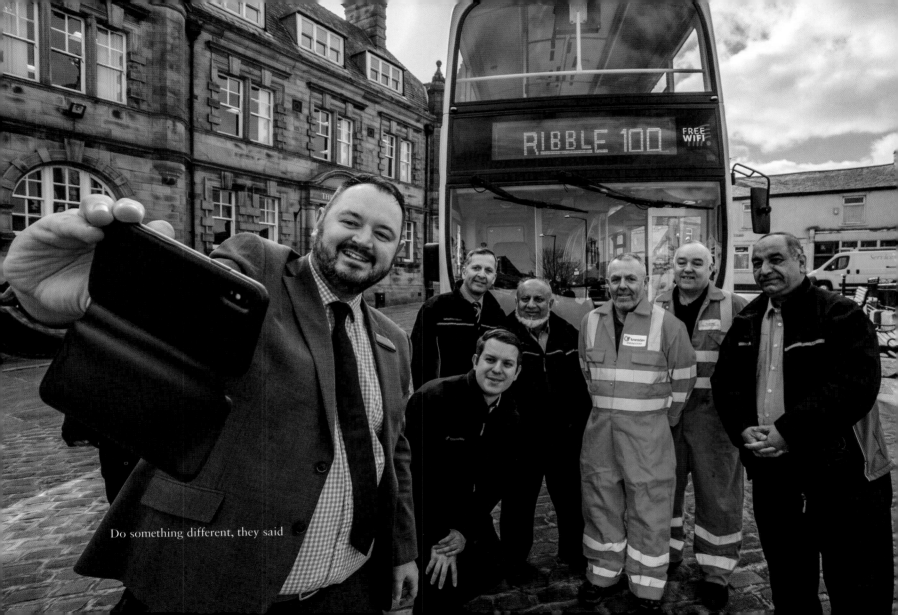

Do something different, they said

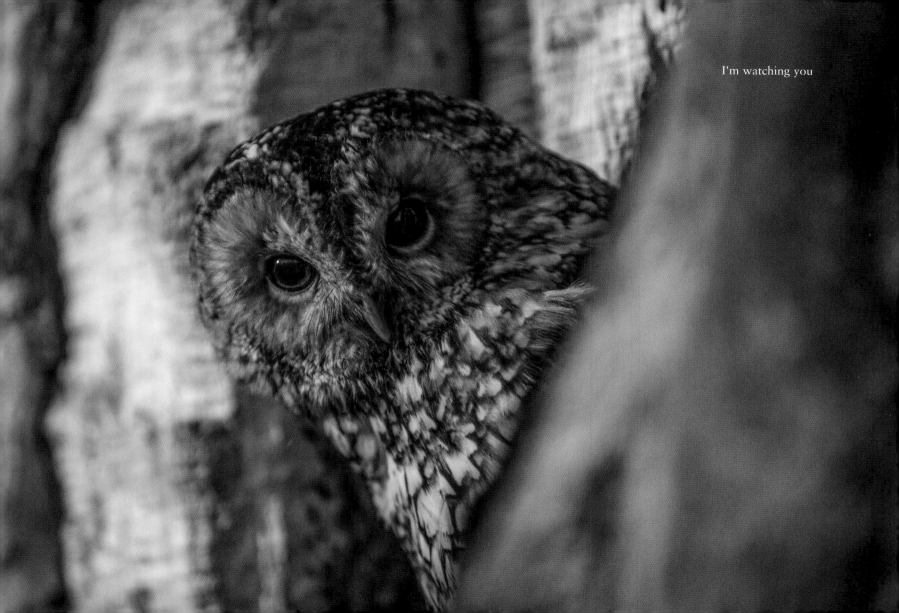

I'm watching you

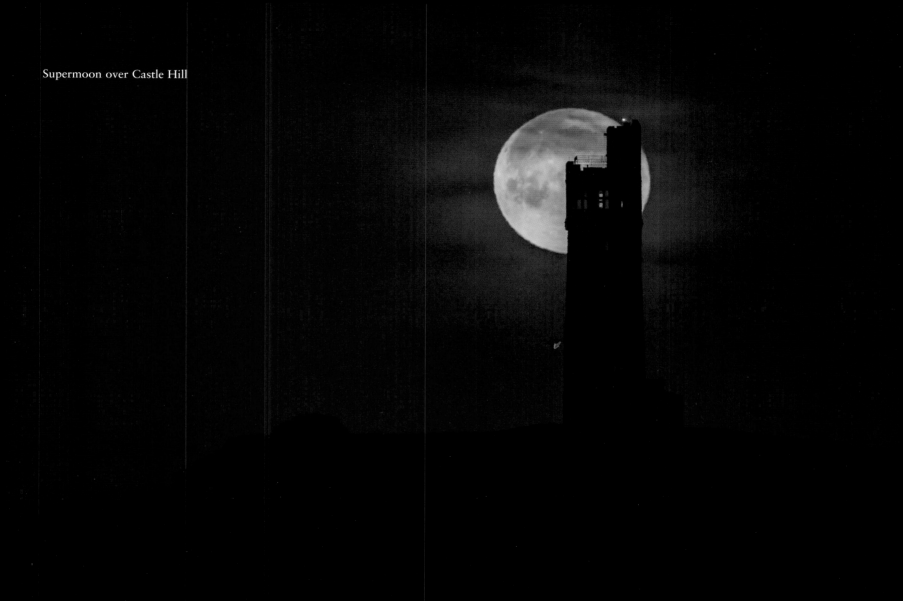

Supermoon over Castle Hill

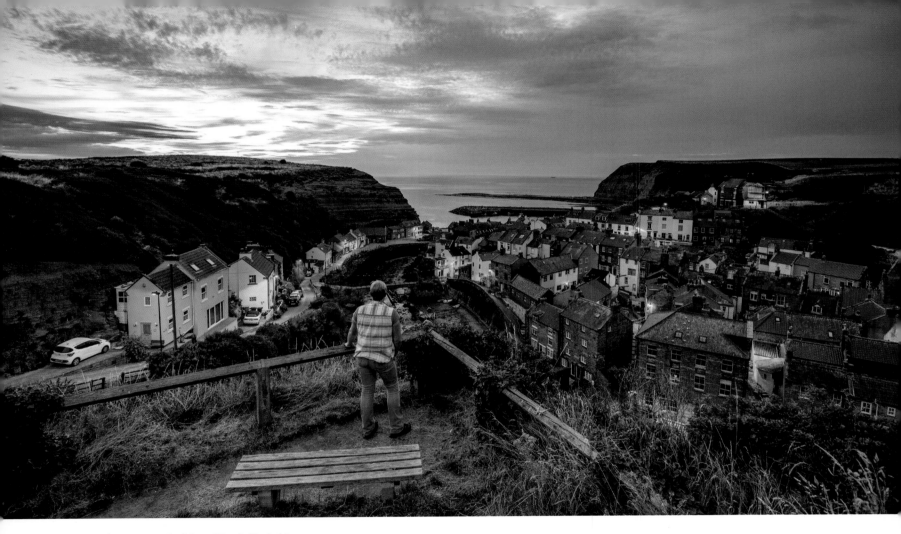

Waiting for sunrise, Staithes, North Yorkshire

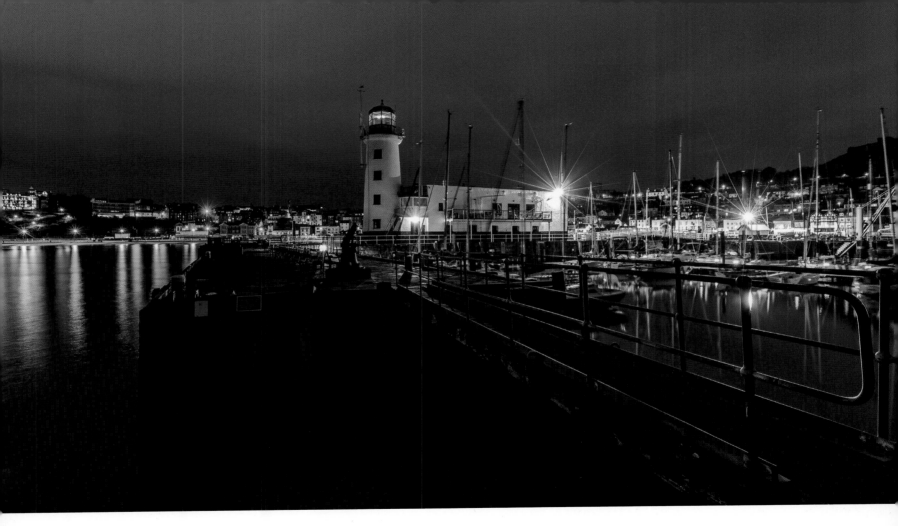

Morning light, Scarborough

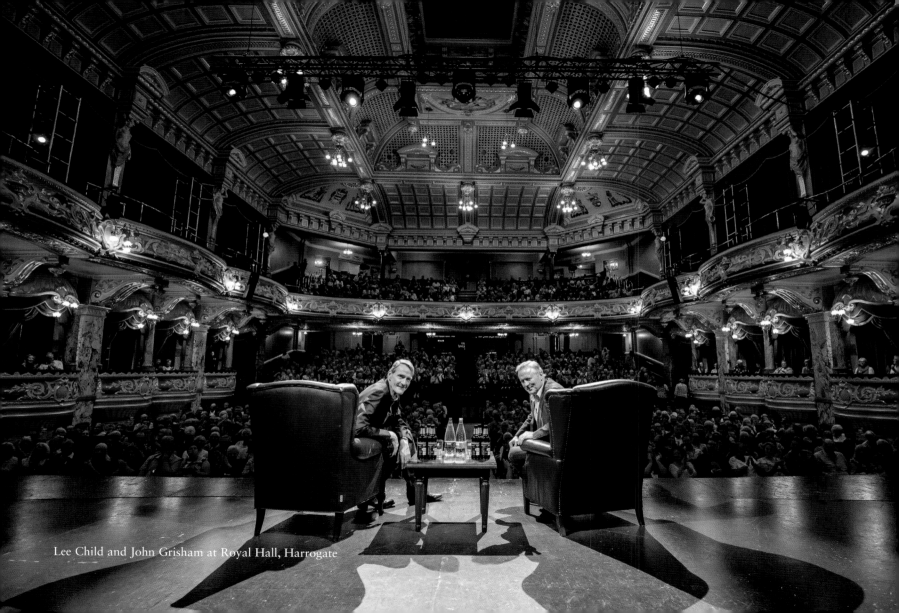

Lee Child and John Grisham at Royal Hall, Harrogate

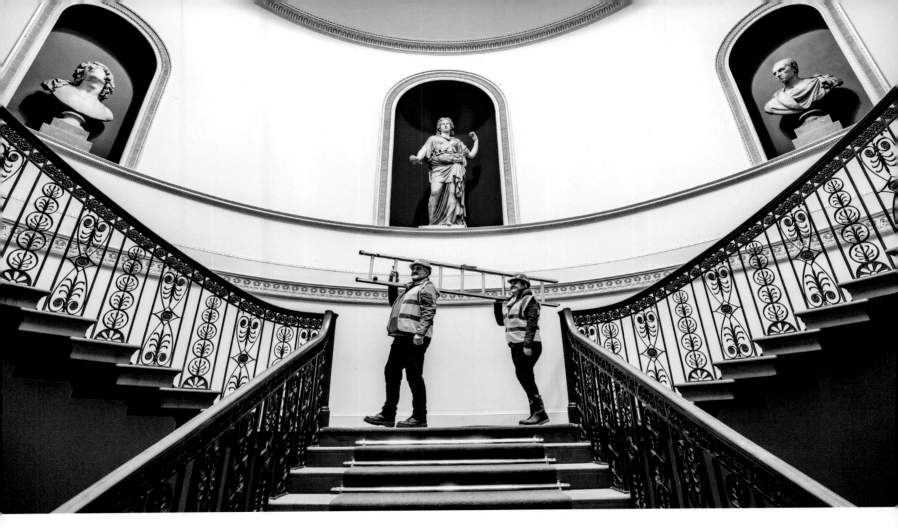

Teamwork at Wentworth House

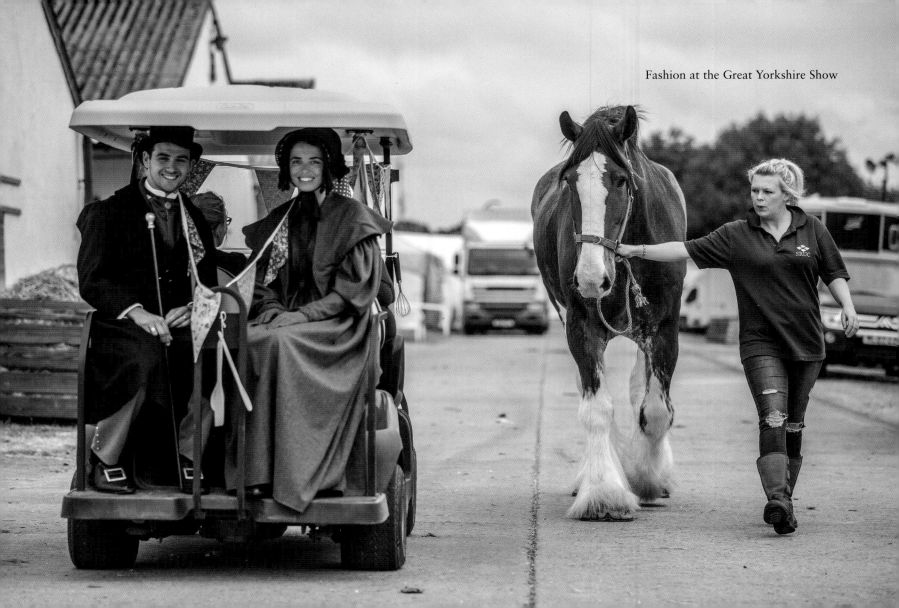

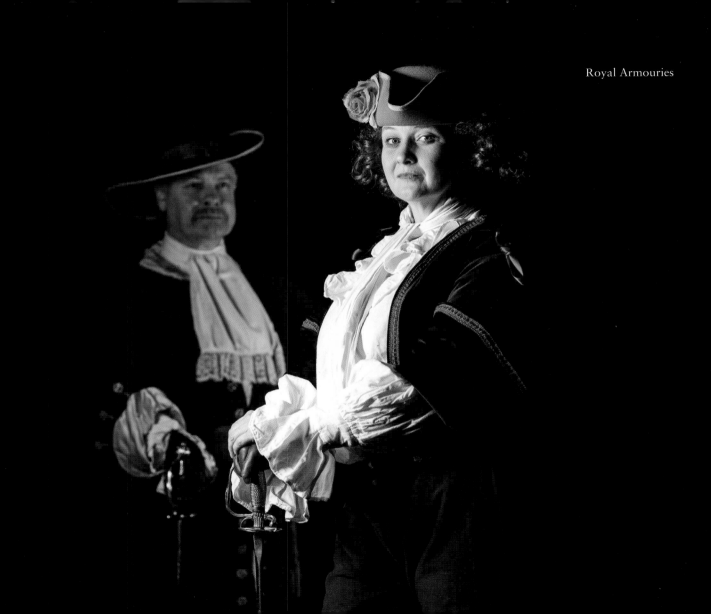

Santa special

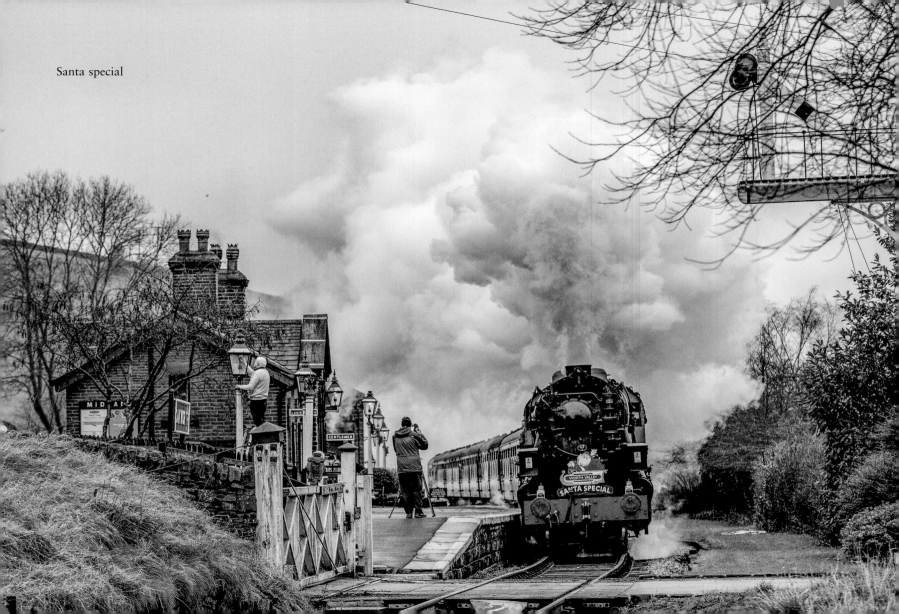

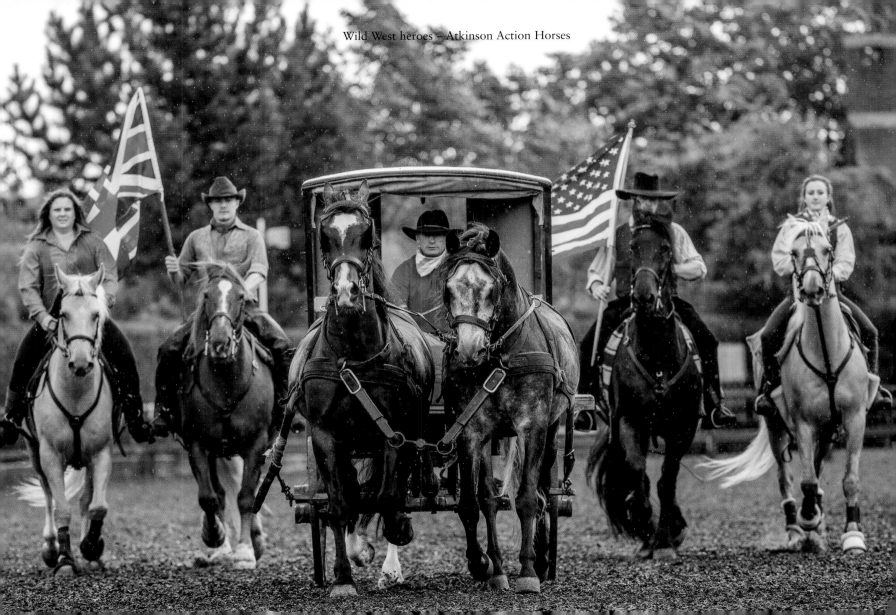
Wild West heroes – Atkinson Action Horses

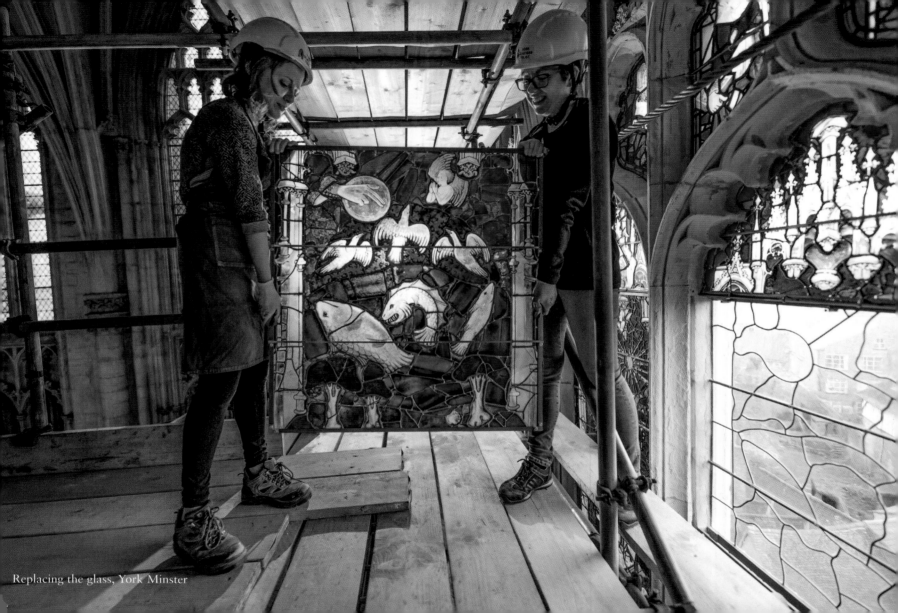

Replacing the glass, York Minster

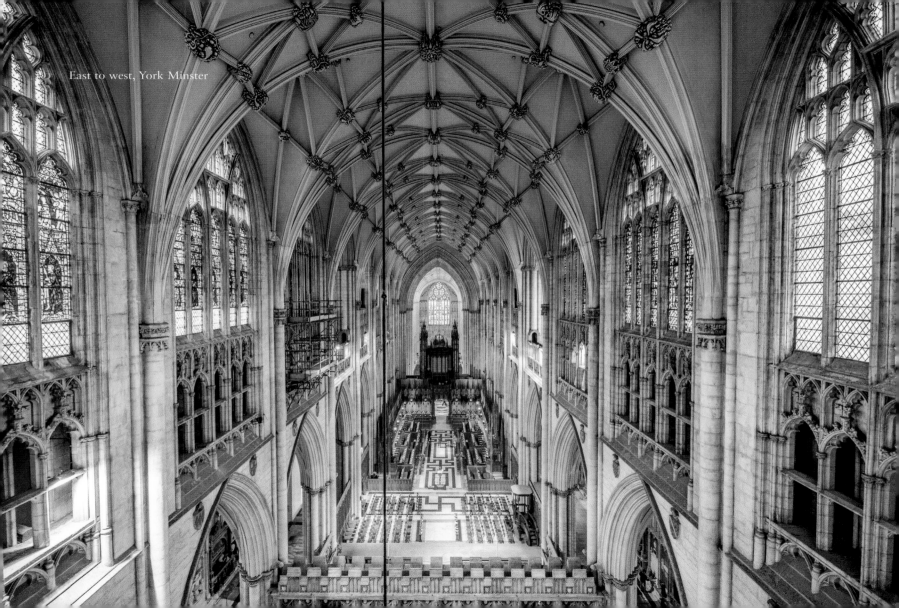

East to west, York Minster

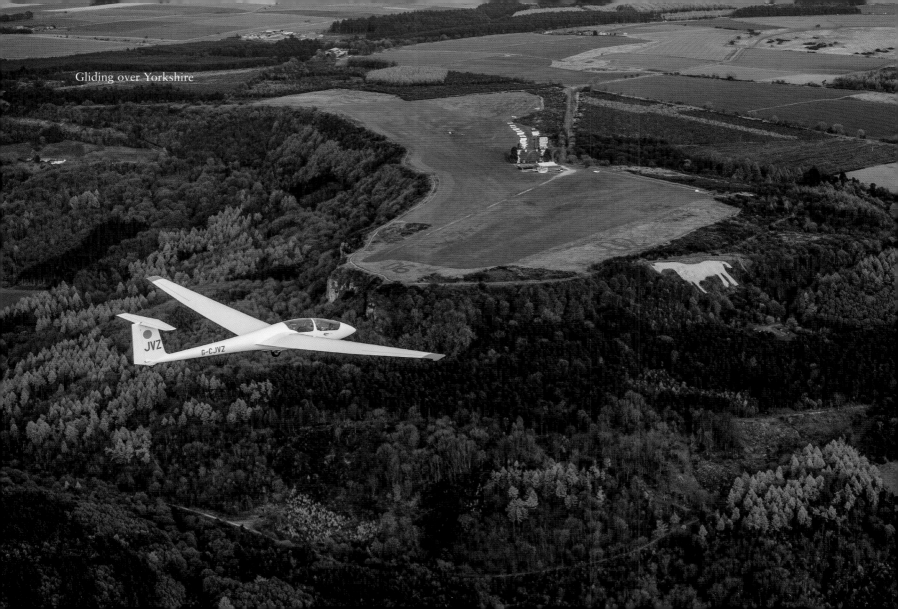

Gliding over Yorkshire

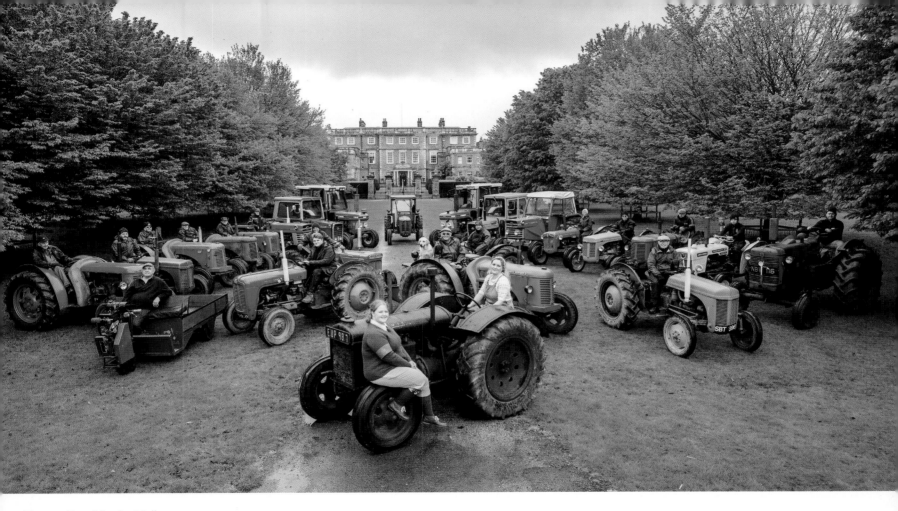

Tractor Fest, Newby Hall

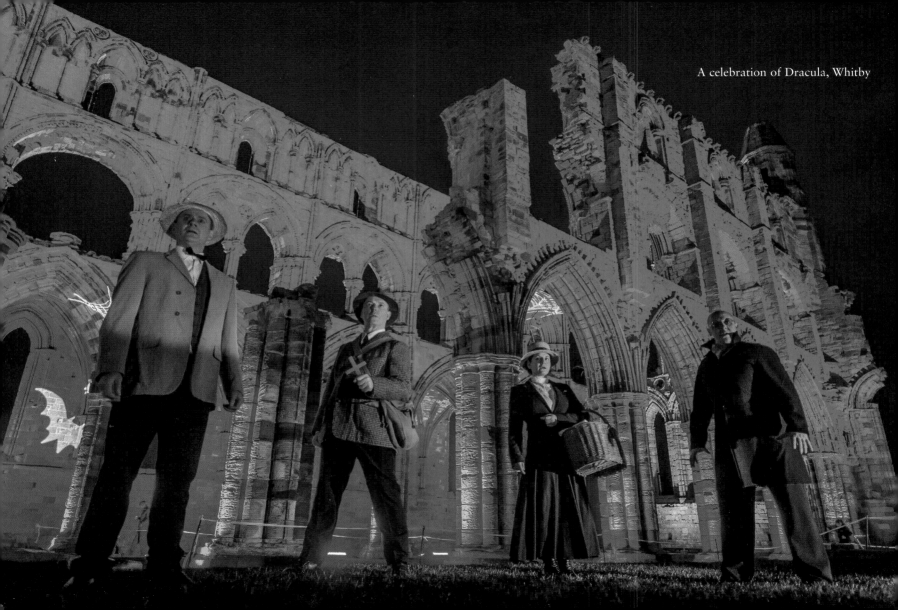
A celebration of Dracula, Whitby

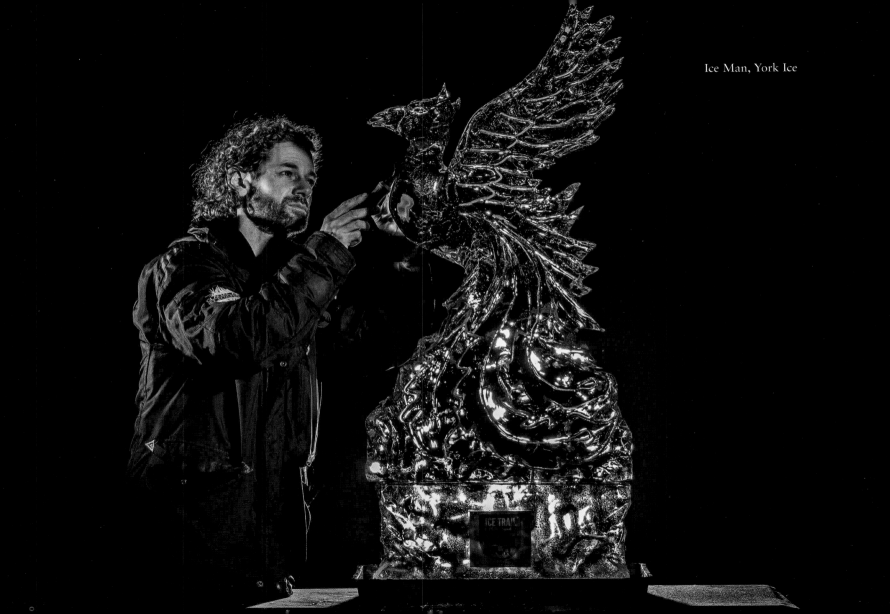

Ice Man, York Ice

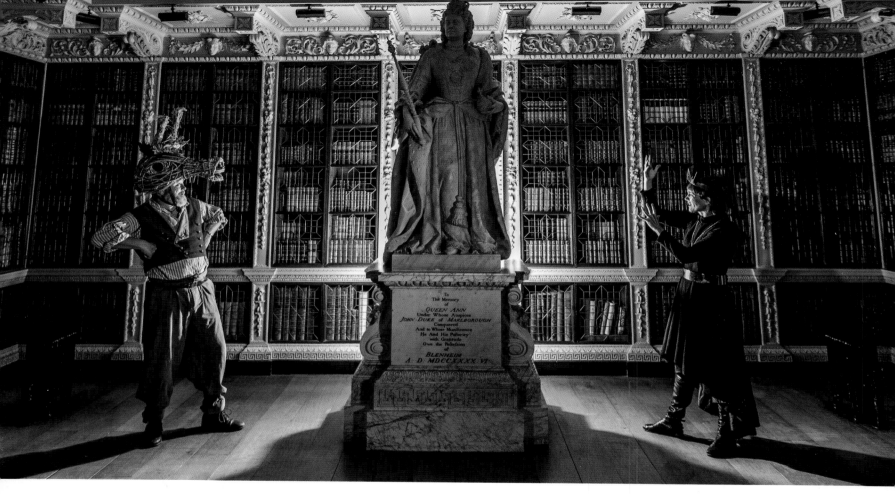

Shakespeare's Rose Theatre